Claudia Bauer

Frida
Kahlo

Prestel

Munich · Berlin · London · New York

Context

"It's better to die on your feet than live on your knees."

Emiliano Zapata,
Mexican revolutionary

Profound political changes...

... were sweeping through Mexico when Frida Kahlo was growing up. Peasants, workers, and native Indians were involved in a struggle for freedom that would give rise to a new government. Life, it seemed, would be better for everybody, and poverty would become a thing of the past. With their explicitly political murals, a group of artists known as the Mexican Muralists, led by the charismatic Diego Rivera, became the artistic spokesmen of the day.

A love of folk art

Above all else, Mexican folk art is colorful. The clash between ancient Mexican cultures and Christian art of the European (particularly the Spanish) Middle Ages produced an extraordinary artistic synthesis. Frida Kahlo attached great importance to her Indian roots, and she loved the brightly colored works of folk art – an art created by and for the ordinary people. Throughout her life, she was a keen collector of Mexican ceramics, whose radiant colors and playful forms occur in her own work. She was also familiar with the ancient cultures of Mexico and with their symbolism, and these too played an important part in her work.

Naive Mexican art like this tin heart stimulated Frida's passion for collecting folk art.

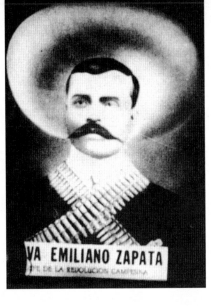

A growing city

After the Revolution, Mexico City experienced a rapid growth in urban development. A program of slum clearance was followed by the construction of many new homes. By 1900, just over half a million people lived in the city, and within twenty years the number had almost doubled. Frida grew up in a better-off residential area called Coyoacán, which became part of Mexico City only in 1950.

The Zapata myth

Frida was three years old when revolution erupted in 1910, the people of Mexico rising against the dictator Porfirio Díaz. Emiliano Zapata became their hero, and it was he, along with Pancho Villa, who organized resistance to the government. Their 'army' consisted mainly of Indians and landless peasants. When government troops suppressed the peasants' movement in 1919, Zapata was drawn into an ambush and shot. Legend surrounds his death to this day: according to one account, he was not shot at all, and will one day return to achieve his political goals.

Art for all

Mexico's new revolutionary government wanted a better life for the country's people. The minister of education, José Vasconcelos, supported a

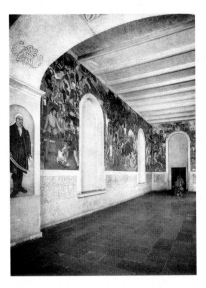

group of artists who were to encourage political and social renewal through large-scale murals. The Mexican Muralist movement was born. Its themes were not just current political events, but also Mexican history, notably the *conquista* (the conquest of Mexico by the Spanish) and its disastrous effects on Mexican Indians. José Clemente Orozco and David Alfaro Siqueiros became central figures of the Muralist Movement, but it was the painter and active Communist Diego Rivera who took people's hearts by storm.

Aztec art

The Aztecs were one of the few Indian peoples whose language included a word for artist, *toltecatl*. According to an Aztec legend: "The artist is educated. He is the skilled one. The true artist works with joy in his heart ... he combines everything into one and makes a harmony." The Mexican Muralists were greatly inspired by their artist forefathers.

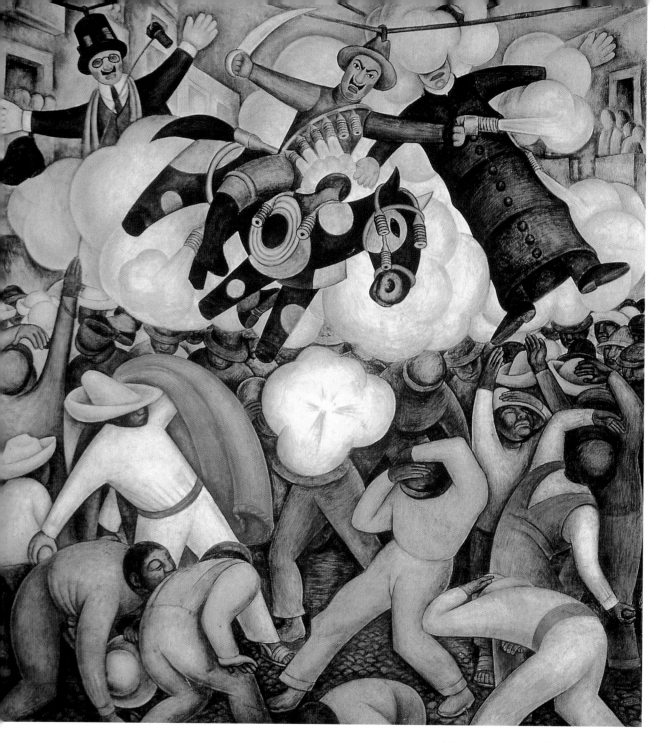

A Mexican custom: here Diego Rivera painted the traditional Easter custom of burning effigies of Judas.

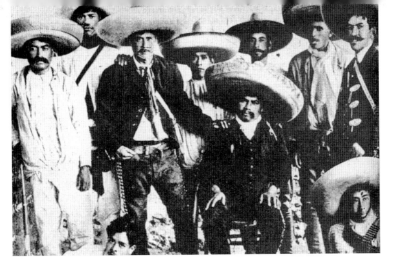

Resisting dictatorship with sombreros and rifles: Mexican revolutionaries fighting for a liberal constitution at the beginning of the 20th century.

¡Viva México!

For Mexico, as for many other countries worldwide, the early years of the 20th century were turbulent and often violent. Political revolution cleared the way for a new type of art whose pioneers became national idols. These heady years bred a rebellious spirit: Frida Kahlo.

Art and revolution

Mexicans are fond of saying that their country has a long past and a short history. Even if it appears to be short, its history is still full of adventurers, heroes, and despots. Europeans wrenched South America from its paradisiacal state of primitiveness and left scorched earth behind them. After three centuries (and a brief spell of Liberalism), the colonial masters were replaced in 1877 by the dictator Porfirio Díaz. Under him, the military, the 'hacienda owners' (the landowners), and foreign investors were now in power.

Just as regressive as General Díaz's inflexible system of government was the art of the day, which drew heavily on the conservative Salon painting of Europe. European-trained

> "As always, Mexico is disorganized and has gone to the devil. The only thing that it retains is the immense beauty of the land and of the Indians."
>
> **Frida Kahlo**

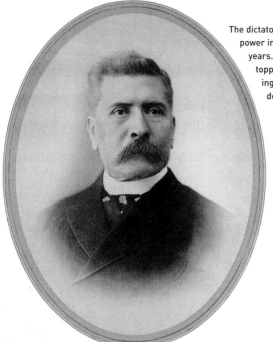

The dictator Porfirio Díaz was in power in Mexico for over thirty years. In 1910, he was finally toppled by a popular uprising that demanded freedom and reform.

artists painted florid works depicting events of national significance or extolling bourgeois virtues. Alongside this 'high art' of the despised privileged classes there exited another type of art that cared nothing for academic rules. The masses loved colorful *retablos* and votive works that were offered to the saints by way of thanks for prayers answered. With its roots deep in Mexican history, this is painting that is original, naive, and emotionally charged. No one in Mexico paid any attention to the avant-garde art movements that were causing a sensation in Europe.

Time ran out for Porfirio Díaz in 1910, when the fury of the Mexican peasants, workers, and a bourgeoisie slowly gaining in power vented itself in a struggle for freedom that would last several years. Emiliano Zapata and Pancho Villa were the glorious heroes of this revolution, by the end of which a liberal constitution was drawn up. A newly installed Minister of Education was to tackle the problem of widespread illiteracy. In his battle against poor education, he found an important ally – art.

Back to basics

Art proved to be the best way to teach the masses about the history of their country. Pictures can both explain events and fire the imagination, and without using words. But how was art to find its public? By moving out of museums and becoming a part of everyday life. Instead of being on small canvases, paintings would now be on large public walls. Derived from the Spanish word for wall, *muro*, the new movement was called *muralismo* (Muralism). In no time at all, it enjoyed great success and was hailed as the Mexican Renaissance in art. Diego Rivera, José Clemente Orozco, and David Alfaro Siqueiros were the leading figures among the Muralists. Rivera had spent a number of years in Europe, where he had become familiar with the latest trends in art. But he had also studied the frescoes of the Old Masters in Italy before

Popular art in Mexico is not concerned with academic rules. Frida Kahlo loved the bright colors and direct expression she saw in naive painting (left).

After the Revolution, the Muralists' socially critical work was popular with the Mexican people (below).

returning to his native Mexico. His work thus combined the traditional narrative art of the fresco with the idioms of modern art.

In their paintings, the Muralists reflected on their Mexican roots, and suggestions of the art of the Mexican Indians are present everywhere in their works. Murals were intended not only to please people, however, but also to educate them. The work of Rivera, Orozco and their comrades-in-arms spread socialist ideas by making them more intelligible to a mass public. Painters, sculptors and illustrators formed a trade union and expressed their aversion to "so-called easel painting and all the art of ultra-intellectual circles." The Ministry of Education, likewise, condemned "bourgeois European painting," and argued in favor of "a Mexican art, public and accessible to all." Frida Kahlo grew up in this period of radical change.

When the Muralists began their triumphant progress, she was a pupil at the National Preparatory School. The political aims of the Muralists filled her with enthusiasm, though she would never paint a mural herself. Instead, she was passionate about Mexican popular art with its colorful and simple *retablos*. In her eyes, panel painting was neither decadent nor "ultra-intellectual."

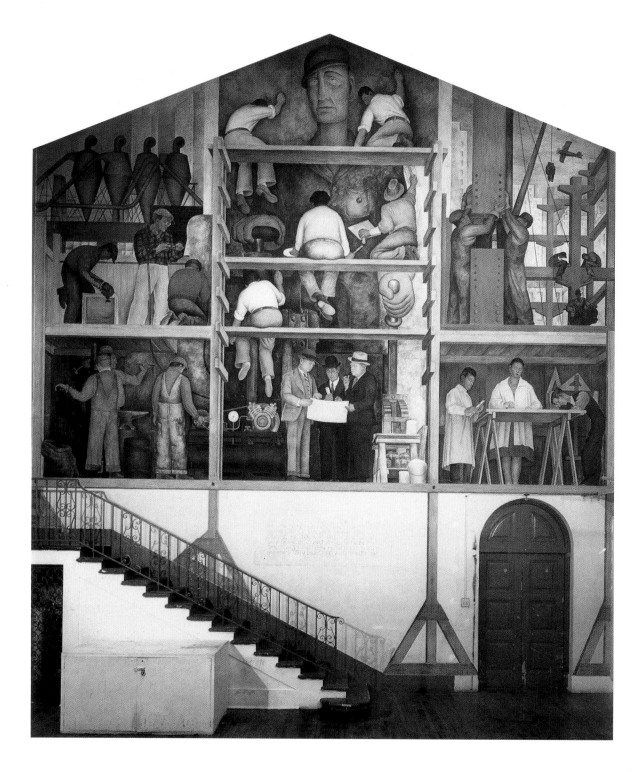

A muralist at work Diego Rivera takes his own work as his theme in this monumental mural at the California School of Fine Arts. Through a number of different sections, it illustrates how a fresco is produced. Sitting on the scaffold and surrounded by his assistants, the artist, brush and palette in hand, is seen in the center, his back to the viewer.

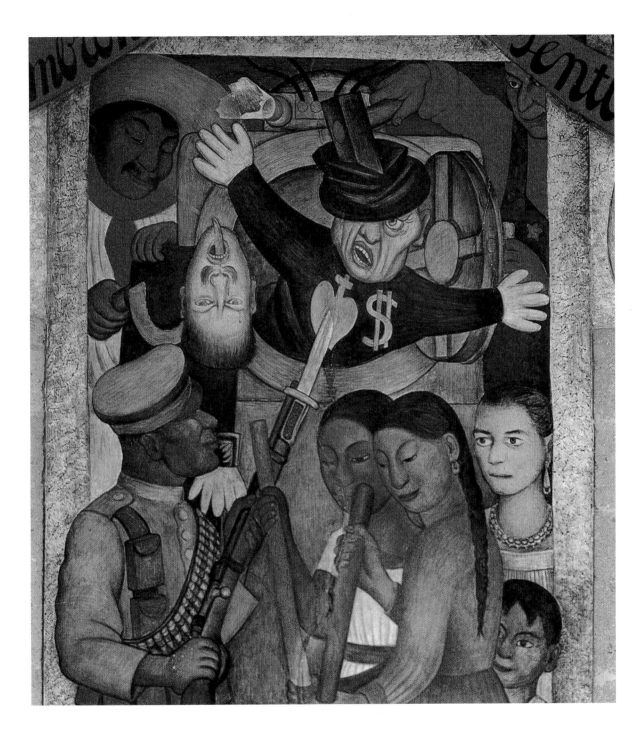

Painting and politics The work of the Muralists was clearly political in its content. In this fresco for the Ministry of Education in Mexico City, Rivera graphically illustrates capitalists meeting a violent end. Despite such overtly anti-capitalist images, Rivera received many commissions from the United States, the 'home of capitalism.'

"Neither Derain,
nor you, nor I
is able to paint
a head as Frida
Kahlo does!"

Pablo Picasso to
Diego Rivera

Overnight fame ...

... was not to be Frida's fate. With no ambition to become a famous artist, first and foremost she worked for herself. Yet she was in the right place at the right time, and in Diego Rivera she found the best supporter she could have hoped for. Slowly but surely, she began to build a name for herself, and in her own lifetime succeeded in being represented both in the Museum of Modern Art in New York and in the Louvre in Paris.

New York, New York

Astonishingly, Frida had her first solo exhibition in the United States, not Mexico. She was 'discovered' by the New York gallery owner Julien Levy, who in 1938 dedicated a solo show to her work that attracted a great deal of attention. This was not the only reason why New York marked an important stage in her career, however. Her participation a short while later in a group exhibition at the famous Museum of Modern Art was also very successful. Nevertheless, Frida at first did not much care for the city in what she called "Gringoland": "The houses look like bread ovens and all the comfort that they talk about is a myth."

Frida's career took off in the art capital of New York.

PARIS

In 1939, Frida was invited to Paris to participate in an exhibition of Mexican art. Her memories of the French capital were not positive: its intellectual and Bohemian circles appeared to her to be decadent and worthless.

Artistically, however, her trip to Europe was very valuable: she was praised by such artists as Kandinsky, Miró, and even Picasso, and in Marcel Duchamp she found a true friend. It was the Louvre that bestowed the greatest honor upon her by purchasing one of her small self-portraits. Frida thus became the first South-American woman artist to have her work enter this great museum's collections.

Frida's pupils

During the 1940s, Frida was among the front rank of Mexican artists. She and Diego were appointed to teaching positions at Mexico City's State School of Art, where the *maestra* soon enjoyed a special status. Diego recalled: "She taught pupils who today are among the leading members of the present generation of Mexican artists. She always insisted on their retaining their own personality in their art and developing it further, and at the same time expressing their social and political ideas through it."

The heiress
Shortly before his death, Diego Rivera assigned trusteeship of his and Frida's property to his patron and confidante Dolores Olmedo Patiño. At the time, Dolores already owned twenty-five paintings by Frida. Although Dolores bought the paintings during Frida's lifetime, no friendship developed between the two women. Rumor has it that Frida was jealous of the relationship Dolores had with Diego. Or was Frida never able to forgive her rival for her long liaison with Alejandro Goméz Arias, Frida's first love?

Patrons and donors

The sale of her work was an important source of both income and independence for Frida, particularly after she and Diego separated. She acquired a number of patrons

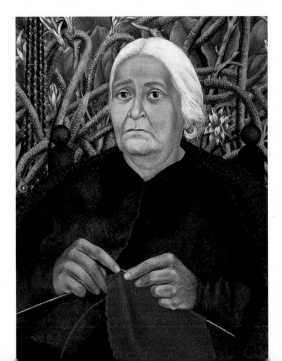

and was happy to accept commissions from them. One of her first patrons was Eduardo Morillo Safa, who had Frida paint a portrait of him and five members of his family, including his mother, Doña Rosita Morillo (left). The painting became one of Frida's favorites. The wealthy American Sigmund Firestone was also enthusiastic about Frida's work. As a souvenir of their acquaintanceship, he had her paint a self-portrait for him.

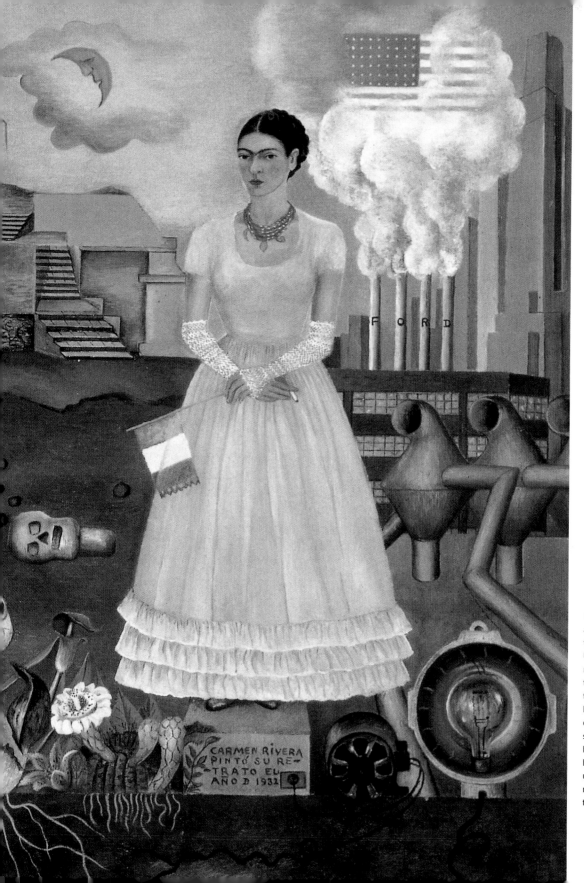

Here Frida stands on a boundary stone between Mexico and the United States. Temple ruins on the left refer to the rich cultural traditions of her homeland, while the chimneys on the right signify the industry of her host country. She has signed the portrait using her second name, Carmen, and the surname Rivera.

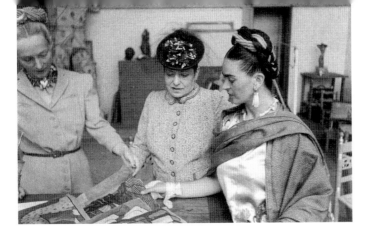

Frida shows watercolors by Diego to the
American collector Helena Rubinstein and
Emmy Lou Packard.

Overshadowed by Diego ...

... for a long time, Frida was seen merely as the woman standing
beside the famous Diego Rivera. Yet when her own great talent
as an artist was discovered, she embarked on a successful interna-
tional career and achieved wide acclaim.

Naturally gifted

Frida never trained 'properly' as an artist. Perhaps she inherited her special
way of looking at the world from her father Guillermo, a photographer who
also enjoyed painting as a pastime. It was Guillermo who arranged for Frida
to have drawing lessons from his friend Fernando Fernández, a graphic
artist, during her time at the Preparatory School. She copied the work of
other artists, and appears to have enjoyed doing so. Many of her letters to
Alejandro, her first love, were decorated with small drawings.

> "I also paint a little, not
> because I think of myself
> as an artist, or anything
> like that, but because
> I've nothing else to do
> here. When I work I can
> forget all my worries for
> a while ..."
>
> **Frida Kahlo**

First steps in art

A terrible accident in 1925 that almost cost Frida her life put an end to the lessons she
had just started with Fernando Fernández. She had to lie in bed for months and was

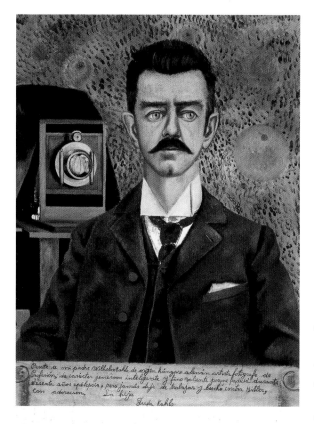

On the scroll beneath this portrait, Frida wrote: "I painted my father, Wilhelm Kahlo, of Hungarian-German origin, artist and photographer by profession, in character generous, intelligent and fine ... With admiration, his daughter Frida Kahlo."

commissions from Mexico and the United States, while Frida was completely absorbed in her role of attentive wife. Her palette and canvases went untouched. Instead, she accompanied her husband wherever he went, and became his most important critic. No opinion was more important to him than that of his 'Fridita.'

The woman at Diego's side

Frida started to work again only gradually. Crises affected her creative impulses in different ways. Sometimes she became listless, at other times she was driven to her easel by bouts of pain and despair. After two of her pregnancies ended in miscarriages, Diego wrote: "Frida started on a series of masterpieces that have no precedent in the history of art. Paintings that exalted the ability of women to endure truth, reality, cruelty and suffering."

As Frida accompanied Diego on his many trips, her life was ruled by his. Diego's arrival anywhere always attracted a lot of press attention, and crowds of inquisitive onlookers tried to catch a glimpse of the

driven to despair by the inactivity forced on her. Was it a stroke of fate that her parents gave her brushes and paint to help her fight the boredom? Frida produced her first paintings between 1926 and 1928 – self-portraits and portraits of her family and friends. Her future husband was the first person whose judgment of her work she sought. He recalled: "For me there was no question that this girl already presented her very own and independent artistic personality. As I was deeply impressed and full of admiration for the girl, it was difficult for me not to praise her."

Marriage to Diego in 1929 limited Frida's productivity. The celebrated muralist was inundated with lucrative

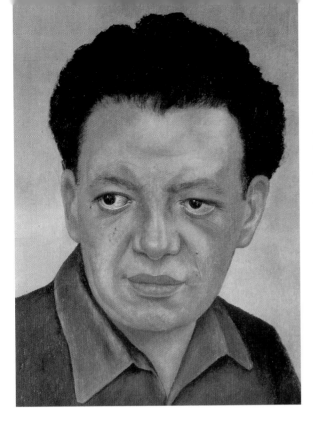

Frida went with Diego on his many working trips. Here she poses in front of a half-finished fresco at the New Workers' School in New York (below). Although she adored him, she painted her husband's portrait only once (left).

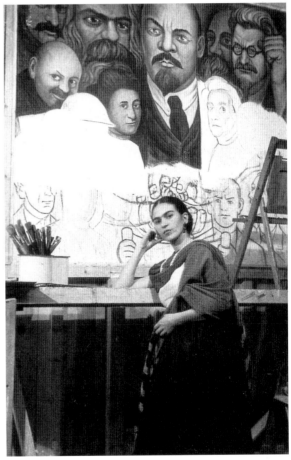

master at work. At most, Frida was noticed when, dressed in her colorful Tijuana costume, she clambered up the scaffold to be beside Diego.

A gift from Picasso

In Mexico City in 1938, about twelve years after she started painting, Frida took part in her first exhibition. Some of her work was shown at the university gallery in a group exhibition organized by Diego. It mattered greatly to him that Frida received recognition as an artist. The time seemed to be just right, because a short time later the New York gallery owner Julien Levy took an interest in her work. Frida was finally seen as an artist in her own right. The exhibition in New York was a huge success and was even mentioned in *Time* magazine. There were some hostile responses to her work – one critic wrote that her subjects "owe more to midwifery and gynecology than aesthetics" – but they did not harm her success.

Frida was able to sell a number of her paintings at Levy's exhibition, and in Mexico, too, potential buyers now showed interest.

The Surrealist André Breton was enthusiastic about Frida's work, and invited her to show it in Paris. The exhibition drew attention to her, and filled European artists with great enthusiasm for her paintings. "There were a lot of people on the opening day ... a big hug from

Frida's talent was 'discovered' by the New York gallery owner Julien Levy (right), in whose gallery she held her first solo exhibition, which was even mentioned in *Time*. A few years later it was the turn of the Museum of Modern Art (below) to show her work.

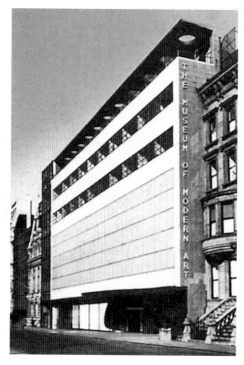

Juan Miró and great praises for my painting from Kandinsky, congratulations from Picasso and Tanguy, from Paalen and from other 'big shits' of Surrealism." Picasso even gave her a pair of earrings. Frida's exoticism went down so well that *Vogue* fashion magazine asked her permission to show her ring-covered fingers on its cover.

Independence

Recognition as an artist was followed by tragedy in her private life. When Diego filed for divorce in 1939, Frida fell into a deep depression that was clearly reflected in her work. As it was important to her not to have to depend on Diego's money, she accepted a number of commissions. Frida's business dealings were not always crowned with success, however, as she showed little willingness to compromise. There was trouble when the author Clare Boothe Luce commissioned a portrait of her friend Dorothy Hale, who had committed suicide in 1938. The author later recalled: "I will always remember the shock I had when I pulled the painting out of the crate. I felt physically *sick*" (page 25).

Even after her reconciliation with Diego, Frida insisted on remaining financially independent. Her success over the next few years gave her a lift, and she was invited to participate in several exhibitions. In her native Mexico, too, where for a long time she did not receive the same recognition as was shown to her in the United States, her reputation grew steadily. In 1942, she became a founding member of the Seminario de Cultura

Frida had to undergo another major operation in 1952. Confined to bed, she painted while lying on her back, just as she had done at the start of her career as an artist.

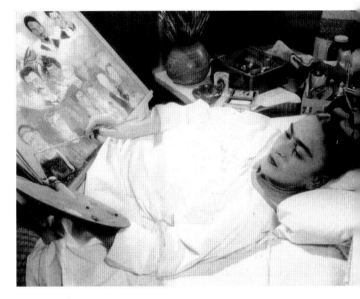

Mexicana, an organization intended to promote the spread of Mexican culture. A short while later, Frida and Diego were asked to join the select circle teaching at La Esmeralda, a new art school under the patronage of the Ministry of Education. Even if her poor health prevented her from teaching there for long, Frida was enthusiastic about her duties. In 1946, she won second prize for her painting entitled *Moses*, which was shown at the annual national exhibition in the Palace of Fine Arts.

Last triumph

During the late 1940s, Frida was repeatedly forced to interrupt her creative work because of poor health. Whenever possible, and thanks to a special easel, she painted lying on her back, just as she had after her accident.

A year before her premature death, the experience of her first solo exhibition in Mexico City was probably her greatest joy. The opening night, which she followed from a bed that had been carried into the gallery, appears in retrospect to be the last triumph of her career as an artist. As often happens, true appreciation of Frida's special place in Mexican art was expressed only after her death: "... her work ... represents one of the most powerful and truthful human documents of our times. It will be of inestimable value for future generations."

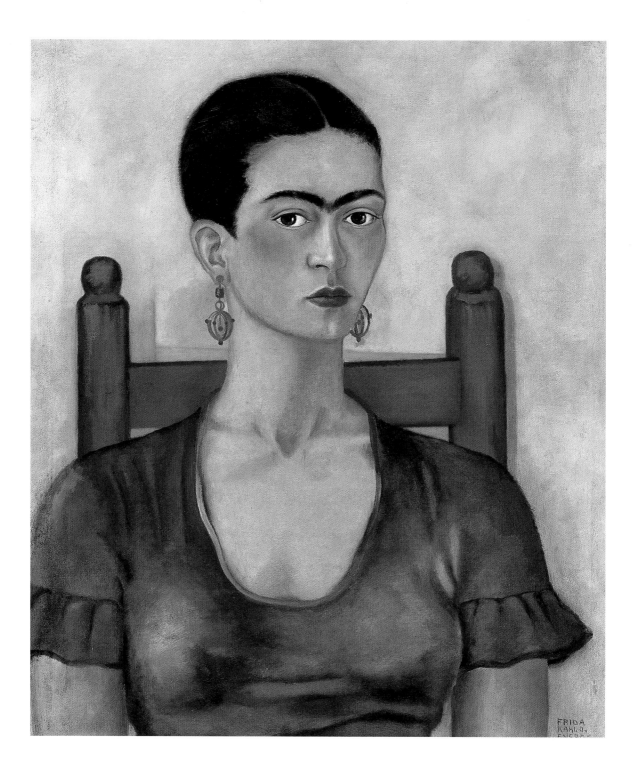

Gazing inwards More than half of Frida's paintings are self-portraits that often seem to be coded expressions of her troubled state of mind. She painted this self-portrait in 1930, when she was twenty-three and recently married to the famous artist Diego Rivera. She gazes at the viewer proudly, a Mexican beauty through and through.

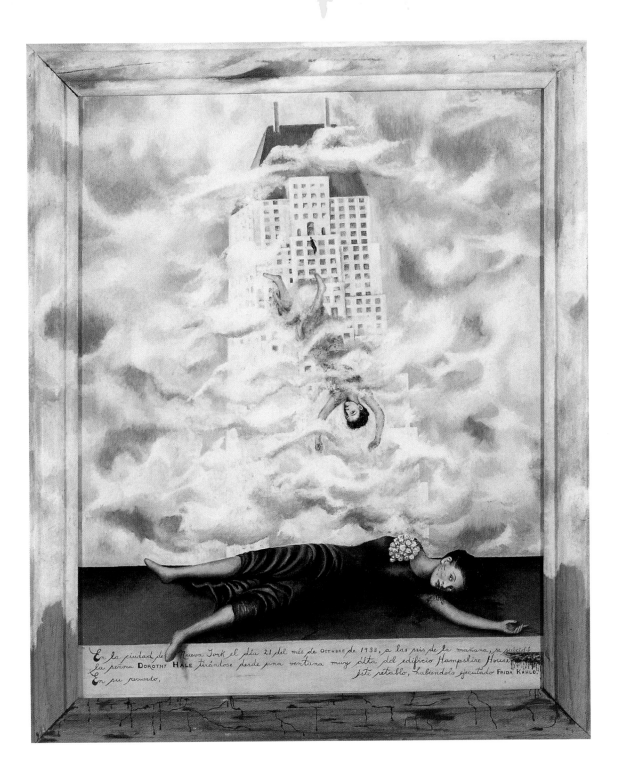

Obituary for a diva "In the city of New York on the 21 October, 1938, at six in the morning, Mrs Dorothy Hale committed suicide by throwing herself out of a very high window of the Hampshire House building. In her memory [text erased] this *retablo*, executed by FRIDA KAHLO." Rather than produce a dignified portrait of the actress, Frida here shows her death in all its horror.

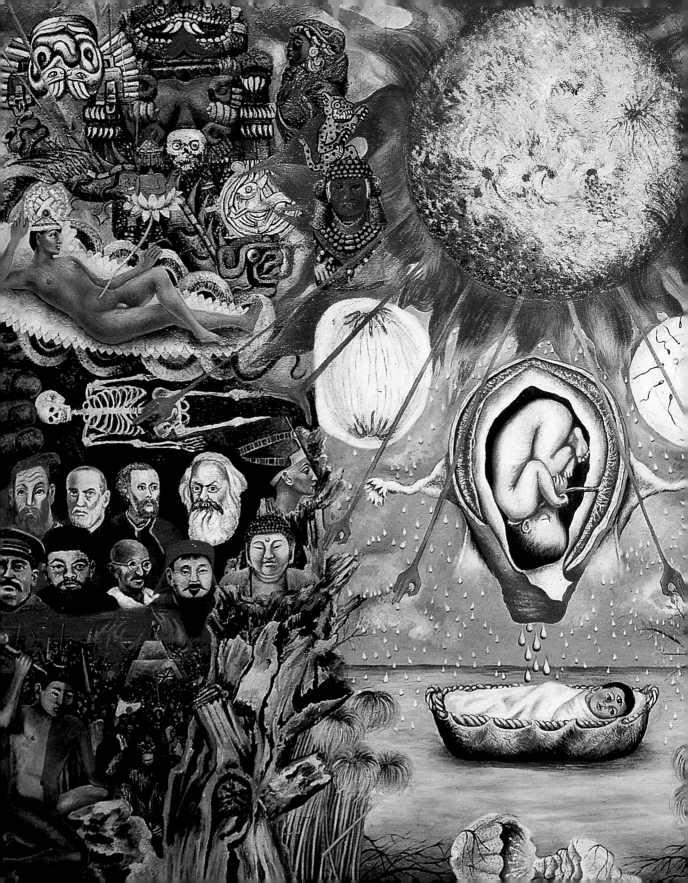

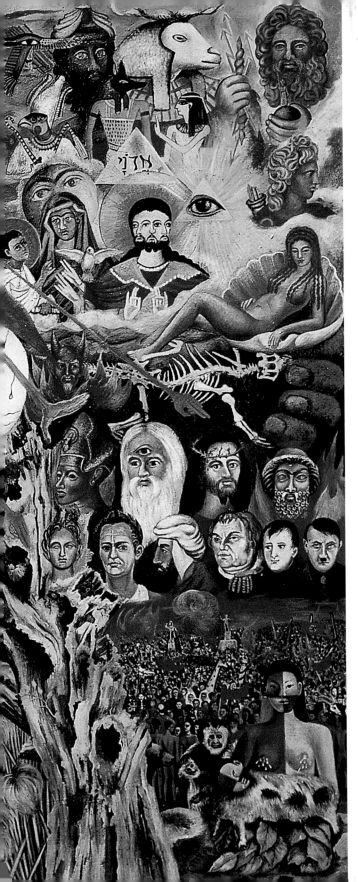

A prize-winning painting For *Moses or Nucleus of Creation*, Frida was awarded second prize at the annual art exhibition at the Palacio de Bellas Artes in Mexico City. She was inspired to paint it by Sigmund Freud's book *Moses and Monotheism*, which a patron had presented to her. Moses is surrounded by a multitude of figures: the artist leaves it to viewers to interpret them.

Art

"I paint
my own
reality."

Frida Kahlo

Frida's style ...

... was unique. Following her own path, she did not allow herself to be influenced by the major artistic trends of the day. But while she stressed her independence, she also freely acknowledged her sources of inspiration: the art of Renaissance Italy, pre-Columbian art, and Mexican popular art.

The art of her ancestors

Covered with mother-of-pearl, this piece of Aztec pottery depicts Quetzalcoatl, the god of creation, peering out of the mouth of a beast.

Frida's Mexican heritage is present everywhere in her work. Before the arrival of the Spanish, Central America produced a number of civilizations, among them the Olmecs, the Aztecs, and the Maya. For these peoples, men, nature, and the gods formed a unity, and highly crafted sculptures and ceremonial objects served as intermediaries between them. Frida and Diego collected not only contemporary folk arts, but also the works of their pre-Columbian ancestors. To house the collection, Diego even had a museum built outside Mexico City, the Museo Anahuacalli.

Frida's works ...

→ were strongly influenced by both her lifelong illness and her stormy relationship with Diego Rivera.

→ are most often self-portraits: gazing into a mirror was essential to her fearless self analysis.

"Your 'Botticelli' is well."

In a letter to her friend Alejandro Goméz Arias, Frida described her first self-portrait as her 'Botticelli.' While studying art books when confined to bed following her accident, she devoted much of her time to the Italian Renaissance. There is no denying a certain closeness between her *Self-Portrait with Velvet Dress* (page 38) and Botticelli's graceful female figures; it certainly explains her nickname. Frida's early exploration of the great masters in her work was of short duration, however.

Help in adversity

Retablos play a special role in Mexican popular art. On small metal or wooden panels, people illustrate the help they have received from the saints and the Holy Family. Frida loved such votive pictures, and adopted their structures and

techniques in some of her work. In this contemporary *retablo*, a Señor Miguel Hernandes offers thanks to Christ for delivering him from a gun battle between soldiers. The story is related both in the picture and in the writing beneath it.

"I never painted dreams."

Frida's fantastical imagery greatly impressed Surrealist artists, who immediately claimed her as one of their own. She, however, distanced

herself from them: "They thought I was a Surrealist, but I wasn't. I never painted dreams." But such artistic independence did not prevent her from fostering close relations with Surrealist artists. Foremost among them was André Breton, in whose apartment she lived during an extended stay in Paris. Both Frida and Diego exhibited their work at the *International Surrealist Exhibition* in Mexico City in 1940.

Surrealism

A central movement within modern art, Surrealism evolved after 1921 from an iconoclastic and anarchic movement, Dadaism. The aim of Surrealist artists was to tap into the subconscious, the dream-like, and the imaginary so as to make creative use of them in overcoming the force of reason and conscious control. The most important representatives of Surrealism were the writer and poet André Breton, and the painters Max Ernst, Salvador Dalí, Yves Tanguy, and René Magritte.

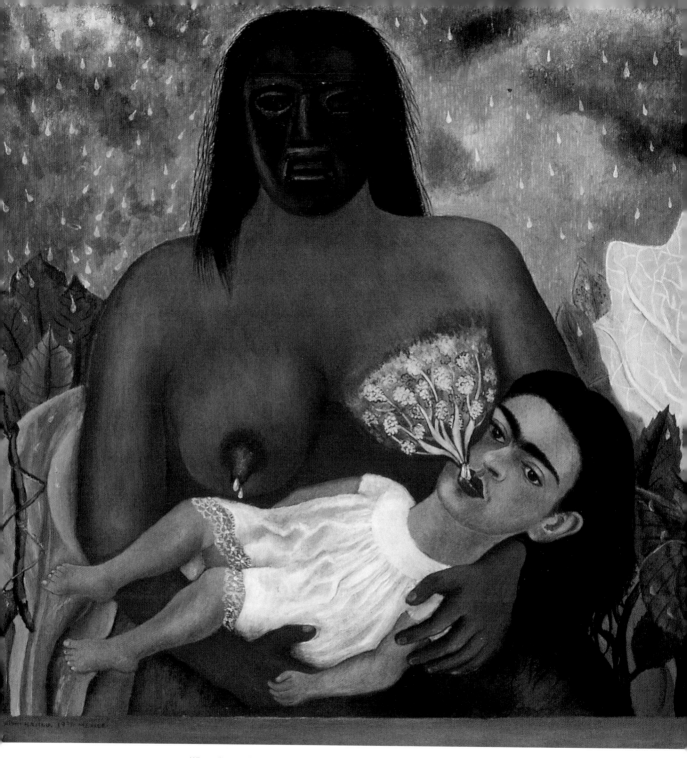

When she was born, Frida was breastfed by an Indian woman. In this painting, her wet nurse is shown wearing a pre-Columbian mask as a symbol of the ancient Mexican culture with which Frida so strongly identified.

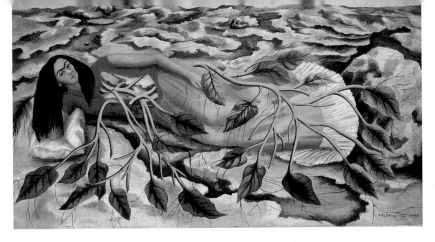

Here Frida paints her Mexican roots literally. Lying upon a Pedregal lava field, she is symbolically united with her native soil.

The canvas as her mirror

"The only thing I can say with certainty about my work is that I paint because I have to, and that I always paint whatever comes to mind, without any other considerations."

A life in paintings

Frida's paintings depict her own story. They are graphic and direct, but also full of symbols, metaphors, and ambiguities. Besides autobiographical references, her paintings contain universal concepts such as femininity, sexuality, desire, deceit, the pain and the cruelty – but also the beauty – of life. Disturbing and enchanting us, Frida has a special place in the art of the 20th century. Self-taught, she reached for a paintbrush and canvas only after a debilitating accident. She developed her greatest talent at the lowest point of her young life and found a way that allowed her to express herself in a unique style: "... I felt I had enough energy in me to do something else other than study medicine, and so without thinking about it much, I started to paint." It was around this time that she acquired her impressive knowledge of European art

"I didn't expect anything from my work but the satisfaction that I gained from simply painting and expressing what I otherwise could not put into words."

Frida Kahlo

When Frida produced this self-portrait, she and Diego were getting a divorce. A necklace of thorns pierces her skin, while she stares ahead, lost within herself.

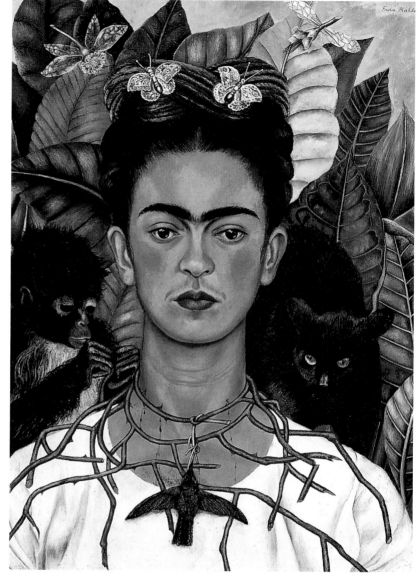

history. The Italian Renaissance and Mannerism appealed to her in particular.

Frida's parents had a mirror fitted to the underside of the canopy over her bed. It seems logical, therefore, that the first painting she produced was a self-portrait. It is reminiscent of the ethereal figures of Botticelli that Frida had studied in her many art books (page 38). To the last, the self-portrait remained the fixed star around which her art revolved. The many images she produced of herself mark out the entire course of her work. Her introspection is both ruthless and eloquent. As she gazes towards us, at times she appears ravishingly beautiful, erotic, and self-confident; at others, a thorn necklace cuts into her flesh, telling of the suffering her husband Diego was causing her.

Mexican heritage

Frida's strong sense of connection with her homeland finds direct expression in her work. She was a Mexican with all her heart and soul. Her maternal grandfather was an Indian, and, as was then customary in wealthier circles, Frida was breastfed not by her mother, but by an Indian woman. These roots were a crucial part of Frida's identity. She often expressed them, as she does

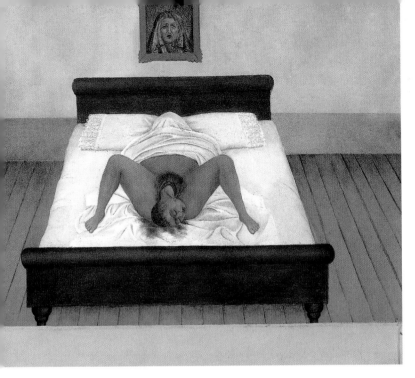

My Birth or Birth is an enigmatic image. Frida had a miscarriage and shortly afterwards her mother died of cancer. Here the artist clearly expresses her deeply distressed state of mind.

in *My Wet Nurse and I* (page 32), which she stated was one of her favorite pictures.

With its colorful, ornate and naive images, Mexican popular art was a key source of inspiration for Frida. This also explains her occasional 'incorrect' use of perspective. Hers is simply a very special narrative style whose point is to show something not realistically but expressively. Her friend, the French poet André Breton, once aptly remarked: "Frida Kahlo Rivera's work is a colored ribbon wrapped around a bomb."

Frida often worked on small-format metal panels of the type used for *retablos*. These are popular votive pictures that give thanks to the saints for help in times of crisis. Besides illustrating a particular event, they also contain some lines of explanation beneath the picture. As Frida's personal dramas usually ended unhappily, her *retablos* were more complex and not an expression of gratitude. They were intended to make her anguish visible. Especially enigmatic is her painting *My Birth or Birth*, in which the scroll along the bottom remains

empty. The artist was unwell when she produced this painting: she had just had a miscarriage and then her mother died. We do not know exactly what she wanted to express with this frightening image. Perhaps she wanted to leave her old self behind and to be 'reborn.'

Surrealist friends

Frida did not allow herself to be influenced by trends in contemporary art: she never tried to be a match for the Muralists around Diego, nor did Cubism or abstract art, trends that were taking Europe by storm, leave any traces in her work. The Surrealists, foremost among them André Breton, certainly thought they recognized a kindred spirit in her. In an essay marking Frida's first major exhibition in 1938, Breton wrote: "... her most recent work is the purest expression of Surrealism, although she produced it with no knowledge of the ideas that guided me and my friends in our work." In the year Breton wrote this, Frida did, in fact, produce her most surrealistic work, her painting *What I saw in the Water* (page 39). The bathwater contains a bizarre

Cubism triumphed in Europe through the work of Georges Braque, Pablo Picasso, and Juan Gris, whose *Fantomas* is shown below. New trends in art from the other side of the Atlantic could not impress Frida, however.

collection of plants, animals and people that appear to come from a fantastical vision.

Despite Breton's enthusiasm and a mutual sympathy between poet and artist, and though her works had much in common with Surrealism, Frida at no point viewed herself as a 'genuine' Surrealist. She was too independent, and was not in the least interested in Surrealist theories. "There is no doubt that in many respects my painting is related to that of the Surrealists, but it was never my intention to produce a work that would fit into that category." Nevertheless, the special position that she claimed for herself did not prevent her, together with Diego, from fostering contacts and exhibiting works at the *International Surrealist Exhibition* at the Inés Amor Galería de Arte Mexicano in Mexico City in 1940.

A language without words

Frida's successes did not go to her head. No prima donna, she reacted modestly to her recognition as an artist. Not seeing herself as a genius with an irresistible urge to stand before a canvas, she never tried to create a myth surrounding her life as an artist. Painting for her was a process of self-discovery based on an analytical – and often painful – gaze inwards. What could better symbolize this than her self-portrait in a wheelchair (page 29), in which she painted her heart on her palette in place of her oil paints? Just as she makes her difficult relationship with Diego a theme of her work, so her progressive physical decline is also present in her paintings. In view of her obsessional analysis of her body, it

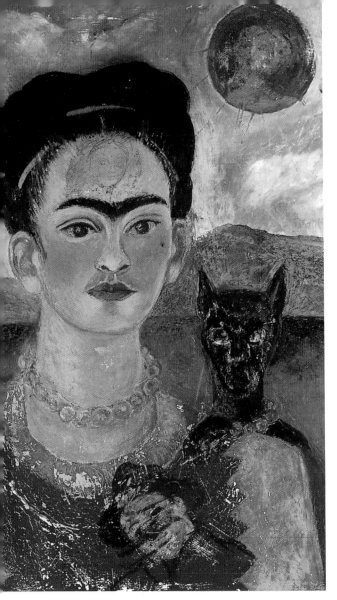

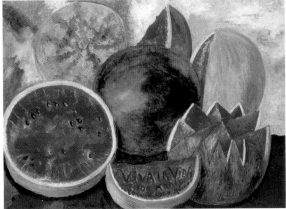

Unlike her early works, Frida's last paintings are seldom highly finished (left). Despite her poor health, she did not lose her courage to face life: her still-life with melons is lively and full of strong color (below).

Dark shadows

Frida's illness, and her inner struggle between despair and the will to live, often characterize her final works. Her commitment to Communism, which until then had never been able to challenge the primacy of her art, now assumed an almost religious character. A diary entry reads: "I have to fight with all my strength to contribute the few positive things my health allows me to the revolution. This is only true reason for which to live." Flags, slogans and the names of her Communist 'saviors,' Marx, Engels, and the rest, now appear in her increasingly agitated paintings. In the last painting she produced, she seems to find herself again. A still-life with melons (above), it is inscribed *Viva la Vida* (long live life!)

becomes obvious that Frida defined herself not least through her suffering, and that she accepted it as a part of herself. Despite all the hardship she suffered, it is astonishing how optimistic she remained: "Nothing in life is more important than laughter. ... Tragedy is the most ridiculous thing."

Following her intense phase with the Surrealists, and with her health deteriorating, Frida's pictures became more complex. More and more often she painted still-lifes that, far from being merely decorative, are full of hidden meanings.

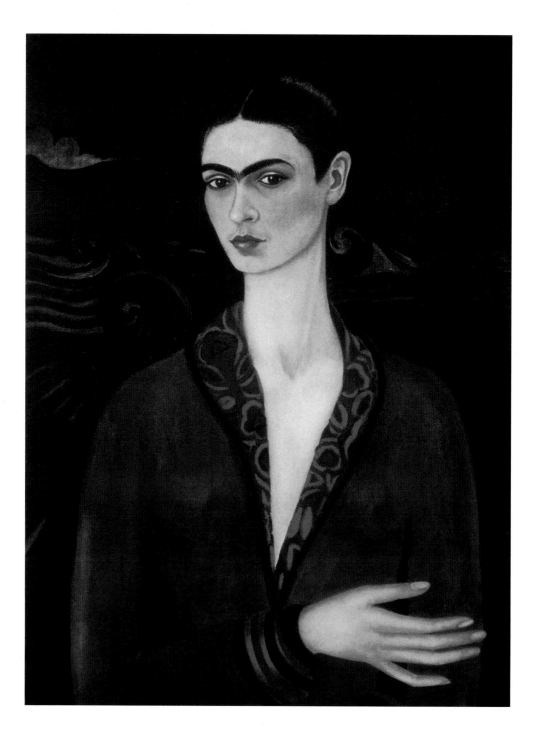

Frida's first self-portrait Confined to bed following a terrible accident, Frida immersed herself in the history of art, and formed a particular liking for the masters of the Italian Renaissance. In her first self-portrait, her pose, long neck and elegant gesture are reminiscent of Botticelli's female figures.

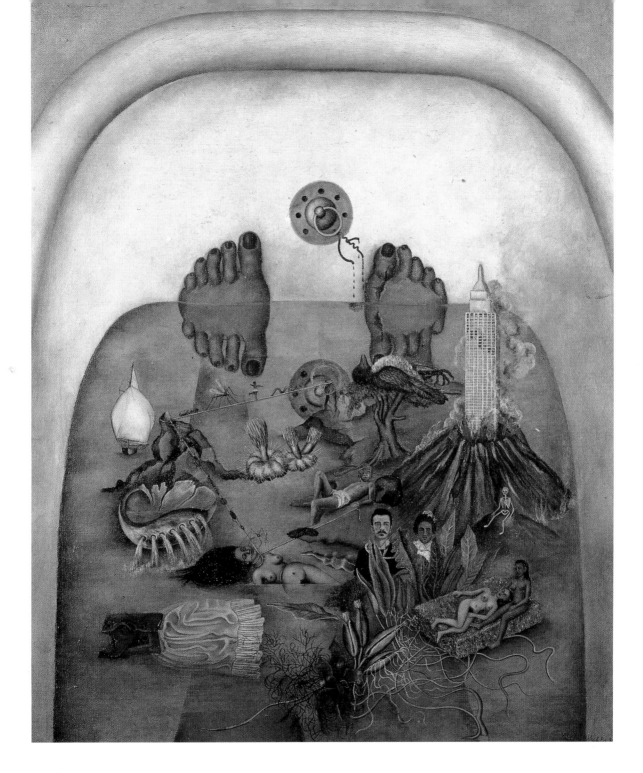

Bathtub fantasy *What I Saw in the Water or What the Water Gave Me* is Frida's most surrealistic work. Many references to other paintings and events in her life are concealed within it. Lower right, her parents look out from behind green leaves. The dress that appears in *Memory or The Heart* (page 103), painted a year earlier, floats in the water on the left.

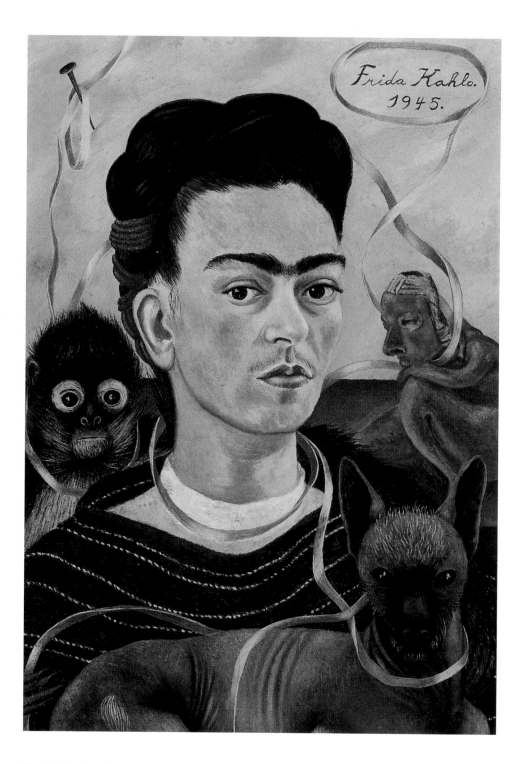

Fond of animals Frida often portrayed herself with animals. In real life, monkeys, dogs, and goats were part of the Kahlo-Rivera household. The pre-Columbian figure on the right is a reference to the Mexican art that Frida and Diego loved to collect.

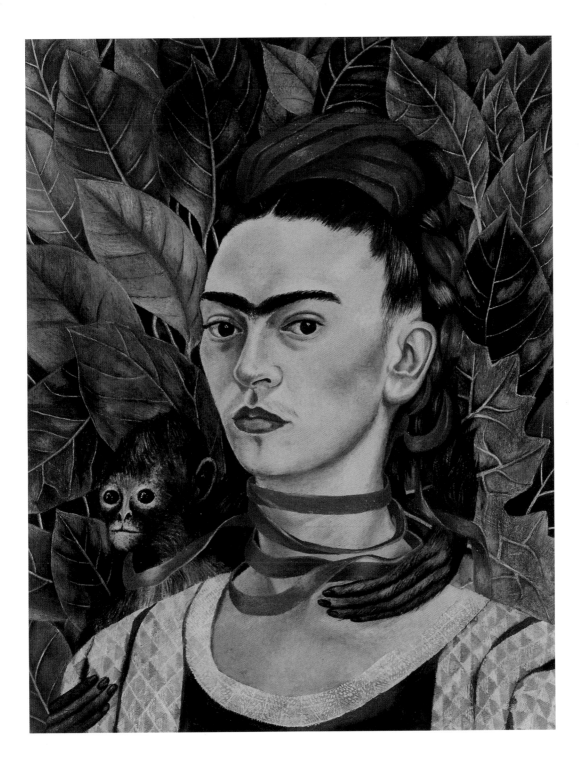

Collector's item This self-portrait with a monkey was produced for the New York collector Nathan Wedeen. Frida painted it in 1940 after her divorce from Diego Rivera. To remain financially independent of Diego, she accepted a number of commissions around this time.

Life

"Take advantage of anything life offers, whatever that may be ..."

Diego to Frida,
1938

Joy and despair...

... were often close companions in Frida's life. She knew a great deal of both: a terrible accident ended her academic ambitions, yet opened a way into art. Her ambivalent relationship with Diego was a source of deep joy and the most terrible pain, and time and again it drove her to produce new masterpieces. Her paintings reflect her own eventful life, and ensure she lives on in our memory.

Family roots

Frida came from a multicultural family. Her father, Guillermo, who was German by birth but of Hungarian-Jewish extraction, emigrated to South America as a young man. By contrast, Frida's mother, Matilde, was a true Mexican: with Indians and a Spanish general among her ancestors, she united the two very different faces of Mexico.

The Kahlo household was almost entirely made up of women: the family had four daughters. Frida was not only the liveliest, but also Guillermo's declared darling because she "is the most intelligent of my daughters. She is the most like me."

The Kahlo sisters and other relatives photographed by Guillermo.

Frida comes alive through...

-→ her frank and passionate letters to family and friends.

-→ her intensely autobiographical paintings.

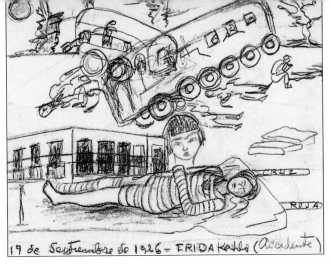

17 de Septiembre de 1926 – FRIDA Kahlo (accidente)

A brush with death

Everything changed forever in 1925, when Frida became the victim of a serious road accident: the bus she was traveling on was involved in a collision with a streetcar. She cheated death, but she would be bedeviled by the after-effects of her serious injuries for the rest of her life. The trauma of the accident was so severe that Frida was never able to convert her experience into a painting. Only an existing *retablo* that Frida retouched (page 50), and a dashed-off pencil drawing (above), suggest how terrible it must have been for her.

Her diary

In the mid 1940s, Frida began to keep a diary that contains more artwork than writing. Her watercolors, drawings, poems and short texts are so cryptic at times that they practically defy explanation. The diary's colorful pages nonetheless convey a vivid impression of Frida's thoughts and feelings. Nowhere else did she express them with such immediacy.

Art and fate

Frida discovered her talent for art only after a serious accident. Painting helped her to banish her low spirits and get over the fact that, after her expensive doctors' bills, there was no money left to pay for the university education she longed for. Her academic career had started promisingly: Frida was among the first girls ever admitted to the 'Prepa,' the school that prepared students for university entrance. Her greatest wish had been to study medicine, yet fate set her on a different course. Would we now know the name of Frida Kahlo had she not boarded that bus?

On the side of the people

Not only art aroused Frida's passion: politics did so too. When she was twenty-one, she joined the Mexican Communist Party and went from rally to rally. This commitment to politics she shared with her husband-to-be, Diego Rivera, who was a central figure in the Communist

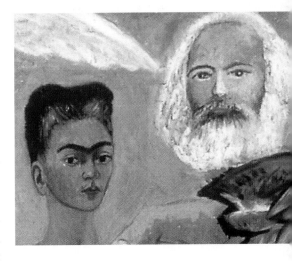

movement. Even if her love of politics was soon eclipsed by her success as an artist, deep down she remained a keen supporter of the Communist cause. Portraits of Stalin and Karl Marx appeared in her late works, and her last public appearance – how else could it have been for Frida? – was at a political rally.

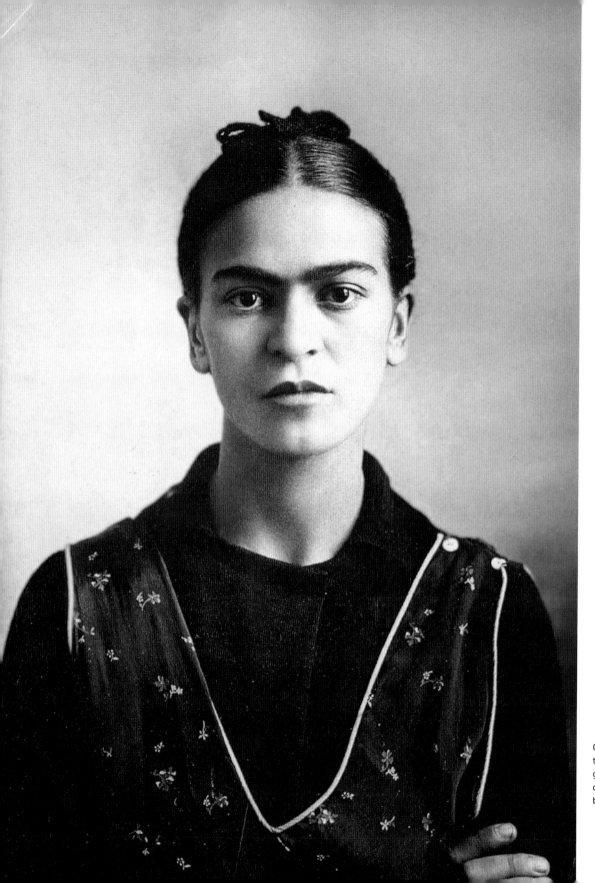

Guillermo Kahlo took this portrait photograph of his favorite daughter on 16 October 1932.

Throughout her life, Frida was close to
her parents, Guillermo and Matilde.

"A restless spirit"

**Frida loved life, even if it did test her to the limits. She survived
a serious accident, came to an 'understanding' with her philan-
dering husband, and made it through a number of miscar-
riages without losing her optimism. Her humor was her source
of strength. As she noted in her diary: "Nothing is more impor-
tant than laughter. To laugh, to abandon oneself, to be light.
Tragedy is the most ridiculous thing."**

A family portrait

Frida was born on 6 July 1907 in Coyoacán, an attractive suburb
of Mexico City. In later life, she pretended that 1910 was the
year of her birth. This not only made her three years younger,
but also delayed her birth until an historic year, that of the Mexican Revolution. She had
her deeply devout mother, Matilde Calderón, to thank for two of her names, Magdalena
and Carmen, and her father, Guillermo Kahlo, for her first name, Frieda, from which she
dropped the 'e' in the 1930s.

Guillermo was actually called Wilhelm. Unlike his wife, he was not from Mexico, but from
Baden-Baden in Germany. At the tender age of nineteen, he left home for good to try his
luck in up-and-coming South America. After his first wife died giving birth to their second

> **"How wonderful life is
> with Frida."**
>
> **Frida Kahlo**

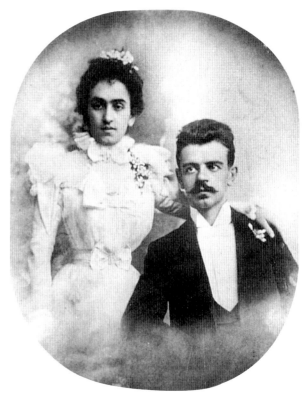

Matilde Calderón and Guillermo Kahlo married in February 1898. Guillermo was taught to be a photographer by his father-in-law.

child, he married Matilde, the daughter of a photographer, Antonio Calderón.

The family was well off once Guillermo too had set himself up as a photographer and had received an important commission from the government to document the country's decaying colonial architecture. Frida and her three sisters, Matilde, Adriana and Cristina, grew up in a spacious blue house that their father had built in 1903. With *My Grandparents, My Parents and I*, Frida in 1936 painted her own version of a family tree in which the family home, the Casa Azul ('Blue House'), is also shown.

At the early age of six, there was a first sign of the serious health problems that would dog Frida throughout her life. Was it an outbreak of polio? Her right leg was affected, and for nine months she was confined to bed. After that her leg did not develop properly, and so earned her the nickname 'Pata de Palo' (Peg Leg) among her playmates.

Pastures new

Frida was fifteen when her father sent her – the only one of his daughters – to the National Preparatory School, known as the 'Prepa.' Guillermo had spotted both her thirst for knowledge and her ambition. By sending her to the school, which was to prepare her for entrance to university, he was giving her a chance that was then available to very few girls. It was not long before she joined 'Los Cachuchas,' a notorious group surrounding the charismatic figure of Alejandro Goméz Arias. He later recalled that Frida "was a restless spirit who refused to comply with the rules. That's why she sought friendship with those students who did not much care for discipline." The boisterous pranks of the Cachuchas, who took their name from the peaked caps they always wore, made life difficult for the school's respectable teachers. It was not just the adventures the

Frida was the third of four daughters born to Matilde Calderón and Guillermo Kahlo. She is four years old in this photograph, taken in 1911.

Even as a child, Frida had a special role within her family. While her sisters and cousin donned their Sunday best for this photograph, Frida posed in a man's suit and wore her hair severely parted.

Cachuchas shared that made them interesting for Frida, however; above all it was Alejandro – she had fallen hopelessly in love with him.

A fateful bus journey

Frida's life changed for ever on 17 September 1925. She and Alejandro were on their way to Coyoacán, this time not by streetcar, but on one of the recently introduced buses that in Mexico were regarded as the latest thing in technological achievement. The buses were very popular with travelers, but were not a particularly safe mode of transport. At a crossroads, Frida's inexperienced bus driver caused his bus to be hit by a streetcar that crushed it against a wall.

"The crash bounced us forwards and a handrail pierced me the way a sword pierces a bull," recounted Frida. A bizarre scene was etched into Alejandro's memory: "Something strange had happened. Frida was totally nude. The collision had unfastened her clothes. Someone in the bus, probably a house painter, had been carrying a packet of powdered gold. This package broke, and the gold fell all over Frida's bleeding body. When people saw her, they cried '*La bailarina, la bailarina!*' With the gold on her red, bloody body, they thought she was a dancer."

Frida's diagnosis was devastating: eleven fractures to her right leg, her right foot dislocated and crushed, her left shoulder dislocated, her spine, pelvis, collarbone, two ribs, and pubic bone fractured. She would suffer from the effects of this accident for the rest of her life. She was confined to bed for long periods, fighting pain, frustration, and boredom. A return to the preparatory

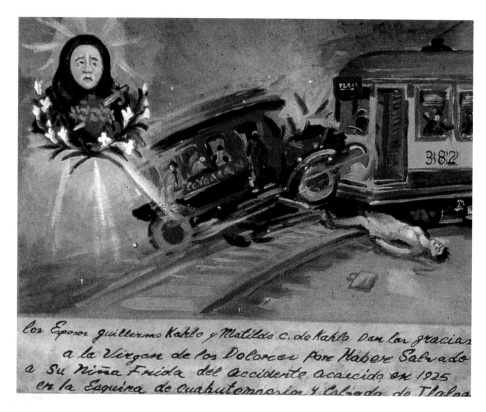

When Frida came across a votive picture showing an accident very similar to her own, she retouched the figure lying on the ground in such a way that it became a self-portrait. The inscription is her own.

school was now out of the question as the money for her school fees had been used up in meeting the expense of treating her many injuries. Frida attempted to banish the excruciating boredom she felt with the help of paint and brushes. She started to paint.

Diego the Great

The consequences of the accident were serious for Frida not only physically. In the long months she spent convalescing, she became estranged from Alejandro, who was sparing with his visits, and who eventually left on an extended trip to Europe. As a result, the first love of Frida's life finally came to an end. Following her deep disappointment, she turned to the circle around Julio Antonio Mella, a Cuban Communist who was an exile in Mexico, and made many new friends, including Mella's lover, the photographer Tina Modotti. In 1928, Frida joined the Mexican Communist Party. And it was around this time that she met the man who would play a dominant role in her life: Diego Rivera.

Diego was already a living legend. He was not only one of Mexico's leading contemporary artists, but also an active Communist notorious for his numerous love affairs. He took a special liking to Frida. In 1928, he immortalized her as a militant Communist in his mural *Arsenal – Frida Kahlo Distributing Weapons*, part of his fresco cycle *The Ballad of the Proletarian Revolution*, which he executed in the Ministry of Education in Mexico City. Diego soon began to court Frida openly.

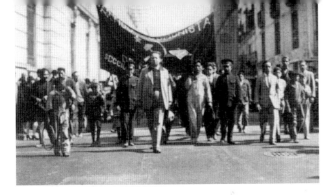

Diego Rivera was known all over Mexico, and not solely as an artist. With politics as his second great passion, he was active in the Communist Party and – as this photograph from the 1920s shows – led numerous demonstrations.

Like Diego, Frida was a member of the Communist Party of Mexico. In this mural, he immortalized her as an activist supporting the people's armed struggle.

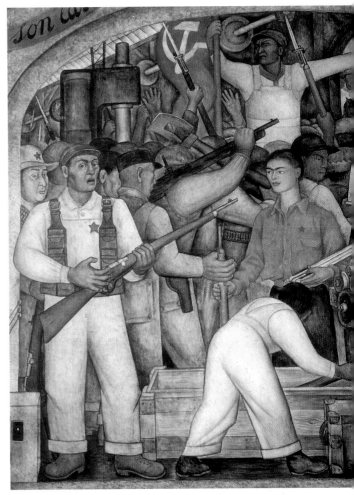

Guillermo Kahlo warned his future son-in-law that Frida was a "devil," but Diego would not be put off. They married on 21 August 1929.

This new phase in Frida's life was marked by a change in her mode of dress. She now discovered the traditional costume of the Tijuana Indians, an ethnic group whose women are considered to be especially imposing, beautiful, and self-confident. In time, the traditional costume worn by Frida came to define her identity. More and more, she began to examine her Mexican roots.

In the land of the 'Gringos'

Diego did not always do justice to his nickname of 'the Lenin of Mexico.' When a lucrative commission was at stake, he set aside his militant Communism and placed himself in the service of the American ambassador, Dwight W. Morrow. These double standards led to Diego's expulsion from the Communist Party in 1929. Expressing her solidarity with him, Frida resigned from the Party. Her bitter realization that Diego was none too particular about his marital vows, and that he was having affairs with his assistants and models, added to the political friction between them. The crisis deepened when, three months pregnant, Frida had a miscarriage. In 1930, Diego received another tempting commission, this time from San Francisco. His reputation as a

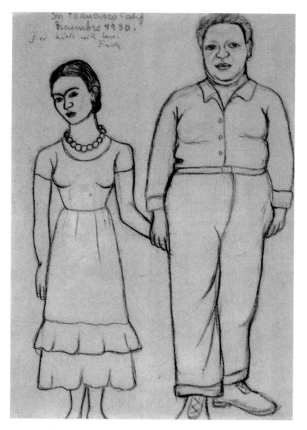

A year after marrying him, Frida worked on a double portrait of herself and Diego (page 86). This drawing is a preparatory sketch in which Diego does not yet hold his palette and brushes in his right hand.

leading Communist did no harm to his renown as an artist, and his work was even in demand in the capitalist United States. Together with Frida, he set off for California in November. Extrovert Diego was a welcome guest in San Francisco's artistic and intellectual circles, and Frida too won admiration. The photographer Edward Weston noted in his diary: "... She wears Mexican dresses, even *huaraches*. When she walks down the streets of San Francisco so dressed, she causes quite a stir. People stop to watch her go by." Frida's enthusiasm was muted, however: "I don't particularly like gringos. They are boring and they all have faces like unbaked bread-rolls (especially the old women)."

With work completely taking up Diego's time, Frida was often left to her own devices. Applying herself to

her painting again, she produced a late wedding portrait that she gave to the art dealer Albert Bender. In it, she portrays herself as a devoted wife standing next to her towering husband (page 86). The palette and brushes he holds leave no doubt about his status as an artist.

Frida's doctor, Leo Eloesser, became a good friend to her. She painted his portrait in 1931. "I feel fine just now. I'm being given injections by a certain Dr Eloesser. He's originally from Germany, but he speaks better Spanish than anyone from Madrid. This means I can tell him exactly how I feel." Frida's trust in Eloesser was so great that she turned to him again and again throughout her life when she was in need of medical advice or emotional support.

In the summer of 1931, the couple returned to Mexico City where, in the district of San Angel, Diego had had a new home built for himself and Frida. It consisted of a large building for his use, and a smaller, adjacent one for his wife's use; only a bridge connected them. This unusual arrangement was a direct expression of

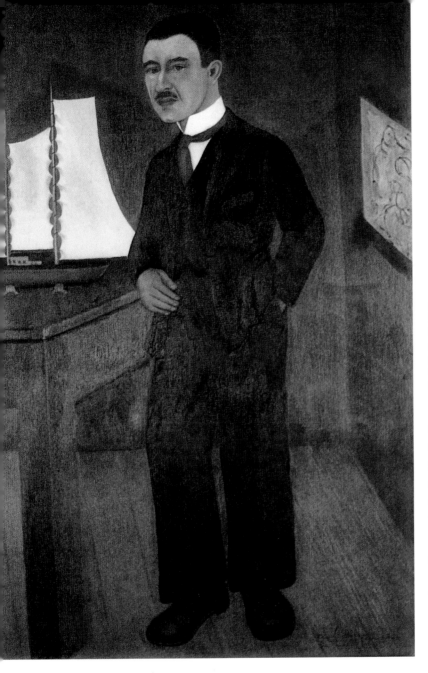

Frida met Dr Leo Eloesser in San Francisco. He went on to become a good friend whose medical advice she sought time and again. By way of thanks, she devoted this portrait to him.

soon firmly established itself in the art world as a major gallery. Shortly after returning to Mexico, Diego was called to New York: the museum wanted to devote a solo exhibition to him. After Henri Matisse, this made Diego the second artist to receive such an honor. Naturally, he did not need to be asked twice and promptly traveled to New York with Frida.

Opening on 22 December 1931, the exibition was a box-office success. Star artist Diego was fêted by the art scene, and he missed not one reception or party. Frida also made new friends and enjoyed the culture on offer in Manhattan, yet she often longed for Mexico. "High society here turns me off ... it is terrifying to see the rich having parties day and night while thousands and thousands of people are dying of hunger ... I don't know if I'm right or not, I'm only telling you what I feel."

his ideas about what constituted a relationship. Much to Frida's chagrin, it was based on maintaining as much of his own independence as possible.

Two Mexicans in Manhattan

The Museum of Modern Art in New York had opened its doors in 1929, and with its sensational collection it

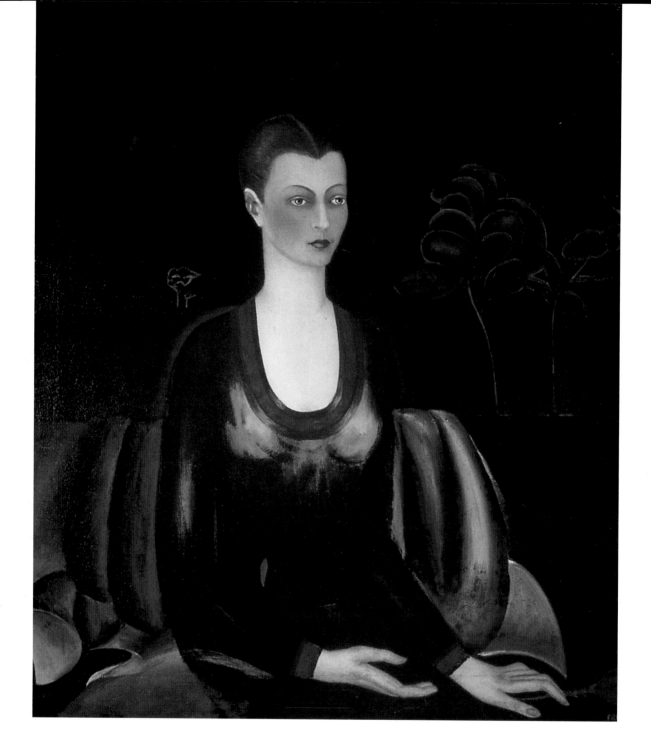

Dark palette The same influences found in Frida's first self-portrait (page 38) predominate in this early likeness of Alicia Galant. Her pose is aristocratic, her hands elegant. Frida had a special liking for Italian Renaissance painting, and adopted for her own image-world much of what she enjoyed in the Old Masters.

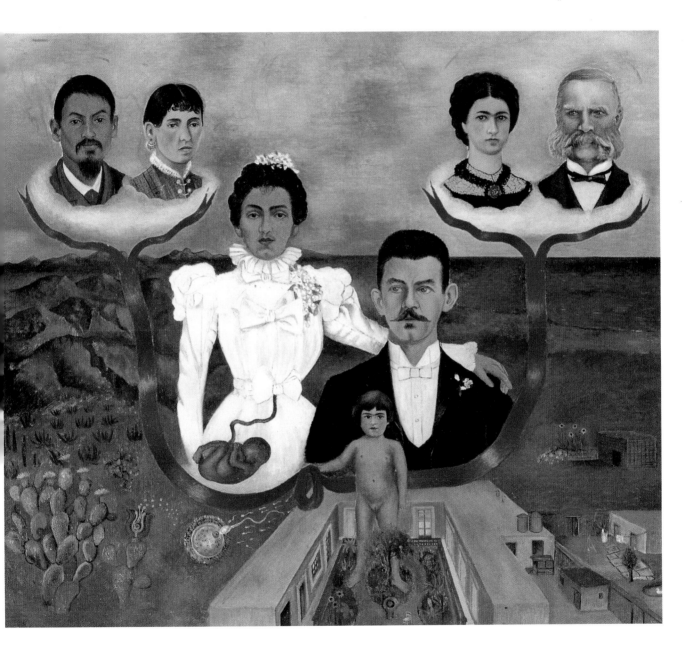

Family ties Frida here portrays herself as a child standing in the courtyard of the Blue House, her dearly loved family home. Behind her, Matilde and Guillermo Kahlo rise out of the Mexican landscape. Frida holds a red ribbon that links her to her grandparents. In front of Matilde, the artist appears as an unborn fetus. Below that are shown a cactus flower receiving pollen, and the moment of Frida's conception.

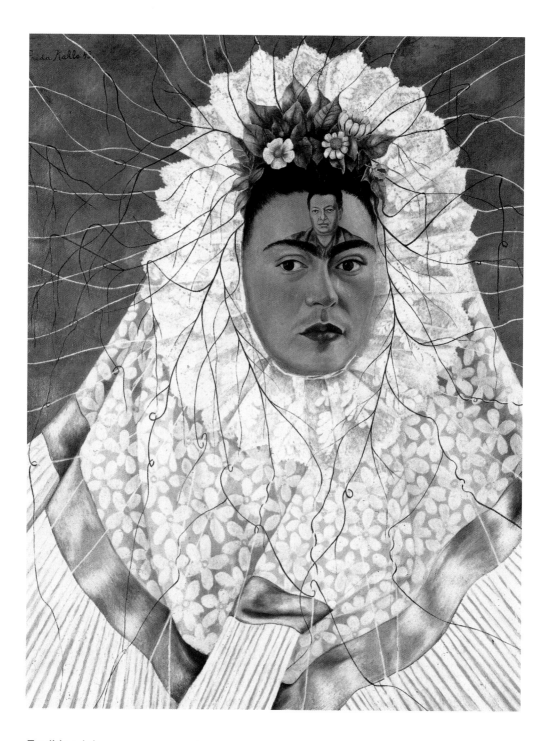

Traditional dress After marrying Diego, Frida began openly to express her pride in her Mexican roots. She was fond of wearing the colorful clothes traditionally worn by Tijuana Indian women. On holidays, they wear white costumes and a striking lace-trimmed headdress, as shown here.

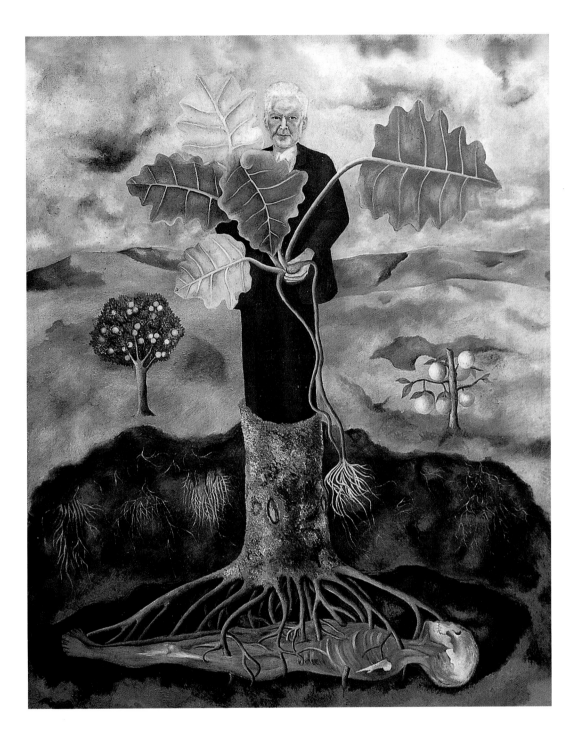

The 'tree man' Luther Burbank was a horticulturist Frieda never met; he was, indeed, already dead when she produced this portrait of him. She and Diego took a keen interest in his theories about reproduction. In Frida's imagination, Burbank is half-man and half-tree, and draws his strength from a buried skeleton.

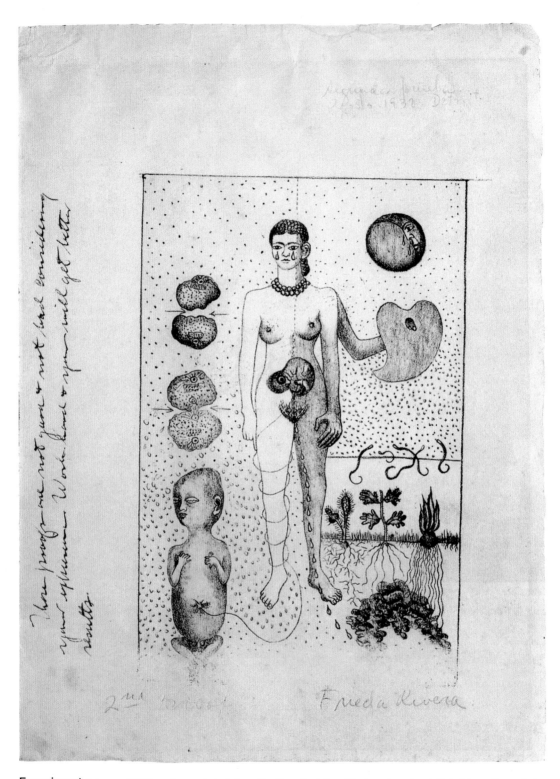

Experiment Only once did Frida make use of a technique other than oil painting. After her miscarriage in Detroit (opposite page), she produced a lithograph that depicts her sorrow at her loss. The note on the left reads: "These proofs are not good & not bad considering your experience. Work hard & you will get better results."

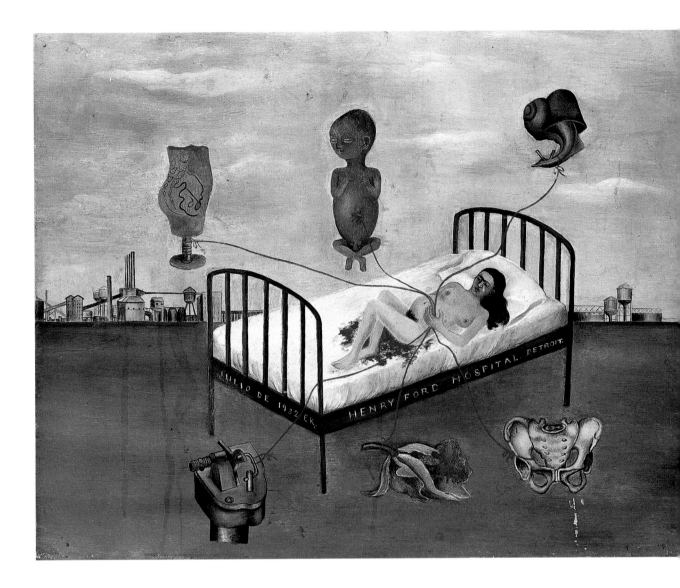

A heavy blow Frida was admitted to Detroit's Henry Ford Hospital in July 1932 because of a miscarriage. With tears streaming down her face, she lies on a hospital bed that seems to float in front of a bleak, industrial landscape. Red threads like umbilical cords connect her with references to the loss of her baby and to sexually charged symbols like the snail and the flower. The landscape intensifies the impression of despair and loneliness.

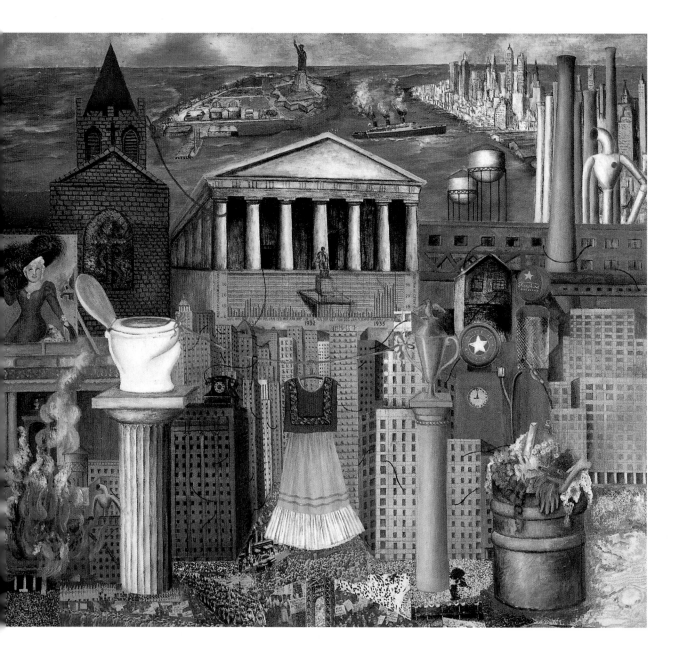

Yearning for Mexico Diego was working on a large mural in New York's Rockefeller Center when Frida, who had accompanied him to the United States, started work on this picture. While he was enjoying his fame as an artist who was the toast of New York's high society, Frida desperately wished to return to Mexico with him. A symbol of her homesickness, her traditional Tijuana dress appears out of place amid the confusion of the city.

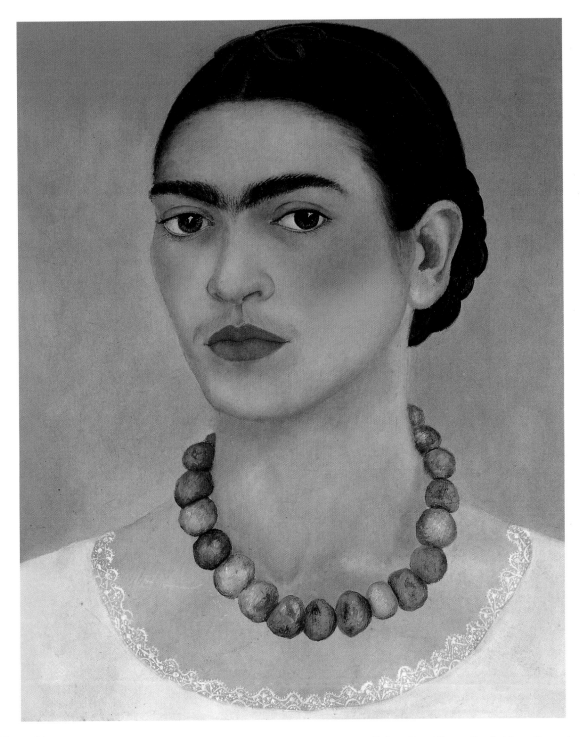

Ray of hope This striking self-portrait with necklace was painted in the same year as *My Dress Hangs There or New York* (opposite page). Nothing in Frida's self-assured gaze betrays the homesickness that was tormenting her at the time. She also appears to have overcome her sorrow at her recent miscarriage.

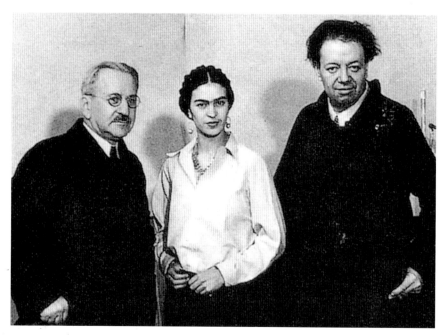

When Diego received a commission from the Detroit Institute of Arts in 1932, he and Frida traveled to Michigan. This photograph was taken during a meeting with the architect Albert Kahn.

Difficult times

In April 1932, Diego and Frida traveled to Detroit, where Diego was to paint a mural at the Institute of Arts. Compared with cosmopolitan New York, Detroit seemed to Frida to be "a shabby old village."

While her Tijuana dresses attracted admiring glances in the streets of New York, in Detroit she was eyed with suspicion. She fell pregnant for a second time and expressed her concerns to Leo Eloesser: "Here I have no one in my family who could take care of me during and after the pregnancy ..." Despite all her doubts, she wanted to have the child, but in July she suffered another painful miscarriage.

Her painting entitled *Henry Ford Hospital* (page 59) was produced a short while later. It conveys an impression of how deeply she was affected by her loss. A second

portrait from around this time, *Self-Portrait on the Borderline between Mexico and the United States* (page 18), makes no reference to the miscarriage at all. Instead, it conveys Frida's sense of being between two worlds: on the left, her native Mexico, which could look back on a rich cultural history; and on the right, the United States and its obsession with material progress. The next heavy blow for Frida followed in the fall, when her mother died of cancer back in Mexico.

There was no end to Diego's American successes. On completing the Detroit mural, he was invited to New York, where he was to decorate the Rockefeller Center with a mural. As ever, Frida was at his side, but her homesickness was beginning to overwhelm her. She expressed her longing for Mexico in her painting *My Dress Hangs There or New York* (page 60).

As Diego was not sparing in his allusions to Communism, the Rockefeller commission ended in

When she discovered that Diego had been having an affair with her sister, Frida cut off her own long hair. Her friend Lucienne Bloch took this photograph of her shortly after.

Back in Mexico City, Diego reconstructed the fresco that had caused such a scandal in the Rockefeller Center. The work's obvious allusions to Communism were the reason it was destroyed in New York.

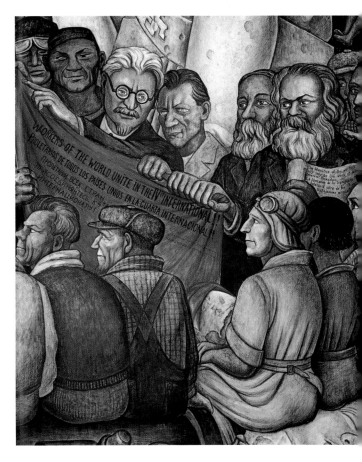

bitter dispute. His client refused to accept the mural and had it destroyed. In December 1933, Diego finally gave in to Frida and the two of them returned to their new home in Mexico City.

Leaving home

Diego made it plain to Frida that he had wanted to stay in the United States. This psychological pressure exacerbated her physical ailments, and on several occasions she had to be admitted to hospital, where the toes of her right foot had to be amputated. The situation worsened when Frida made a terrible discovery: Diego was having an affair with her beloved sister, Cristina. Frida moved out of the marital home, but after a few months returned to the arms of her unfaithful husband.

Asylum for Trotsky

Exclusion from the Communist Party did not end Diego's political commitment. For some time, he had been enthusing about the Russian revolutionary Leon Trotsky, whom Stalin had deported from the Soviet Union. When Norway, Trotsky's place of exile, refused to extend his right of residence for fear of Russian sanctions, Diego successfully pleaded his case with the Mexican government, and Trotsky was granted permission to enter Mexico. On 11 January 1937, he and

his wife, Natalia Sedova, arrived in Mexico City, Frida acting as their guide. Trotsky and his wife were allowed the use of the Blue House, where Guillermo lived alone following his wife's death. Frida was deeply impressed by the educated and eloquent revolutionary. She wrote to her friend Lucienne Bloch that the best thing that ever happened in her life was Trotsky's exile in Mexico. To Natalia's dismay, an affair soon developed between her husband and their attractive hostess. Their liaison was only of short duration, however, and was already over when Frida gave Trotsky a very special birthday present, her *Self-Portrait Dedicated to Leon Trotsky* (page 66) in which she appears in Tijuana costume in all her beauty.

Initial success

"As you can observe, I have painted. Which is already something, since I have spent my life until now loving Diego and being a good-for-nothing with respect to work ..." Frida wrote this to her friend Ella Wolfe in 1937, at a point when her own work was becoming more

important to her and she was able to show it for the first time in a group exhibition.

Her next one was not long in coming. The New York gallery owner Julien Levy had heard of Frida's extraordinary work and invited her to exhibit in his gallery. In October 1938, Frida again set off for Manhattan to prepare for the show. As photographs

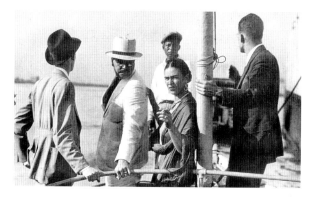

Diego spoke to the Mexican president to ensure that asylum was granted to the Russian revolutionary Leon Trotsky. Frida was among the party that welcomed him at the port of Tampico. Trotsky arrived in Mexico City on 11 January 1937. This photograph was taken en route to Tampico.

When Frida showed her work in Paris, she stayed in the home of fellow artist Marcel Duchamp. Among what she called the "good-for-nothings" of Paris, he proved to be her only real friend.

taken during her visit show, Levy was taken with more than her artwork.

Old Europe

André Breton suggested to Frida that another exhibition of her work could be organized, this time in Paris. She was reluctant to begin with because Diego had not gone with her to New York, and she would have to travel to Paris alone. Diego placated her in a letter: "Don't be silly. I don't want you for my sake to lose the opportunity to go to Paris. Take advantage of anything life offers, whatever that may be, provided it is interesting and can give you some pleasure."

Frida set off for Paris in January 1939, staying first with André Breton and his wife Jacqueline. Organization was obviously not Breton's strong point: Frida's paintings had not yet been cleared through customs, nor had a venue for her show been found. To cap it all, Frida came down with a kidney infection and had to be admitted to hospital. Out of ill temper, she wrote to her friend Nickolas Muray: "I bet you my boots that in Breton's house was where I got the lousy colon bacillus. You don't have any idea of the dirt those people live in, and the kind of food they eat. It's incredible. I never seen anything like it before in my damn life."

The artist Marcel Duchamp, also a fan of Frida's work, saved the day. "The only one among this rotten people who is a real guy," he had Frida, once she had recovered, move in with his American partner and saw to it that her work was included in a group exhibition entitled *Mexique* at Pierre Colle's gallery in Paris. Among pre-Columbian sculptures, 19th-century paintings, and the work of contemporary photographers, Frida's paintings became the main attraction. Even the venerable Louvre purchased one of her pictures.

Frida was nevertheless glad when she set off back to New York in March 1939. The intellectual circles of Paris were the last straw for her: "You have no idea the kind of sons-of-bitches these people are. They make me sick. They're so damn 'intellectual' and corrupt I can't stand them any more ... shit and only shit is what they are ..."

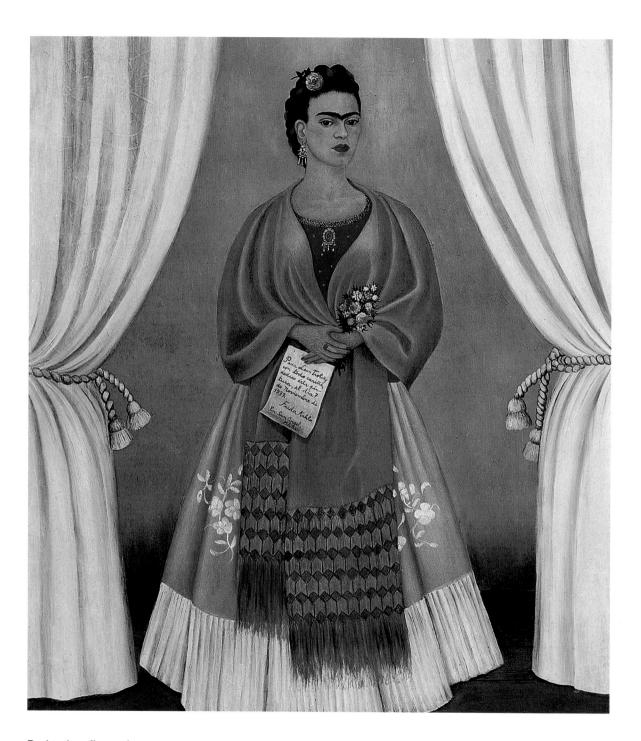

Red to her fingertips The self-portrait that Frida presented to Leon Trotsky is full of hidden references to his background in politics. The white curtains allude to the 'The Whites,' the reactionary opponents of the Russian Revolution against whom Trotsky fought. With her bright red lipstick, red blouse and red fingernails, Frida identifies herself as a 'Red,' and therefore loyal to Trotsky.

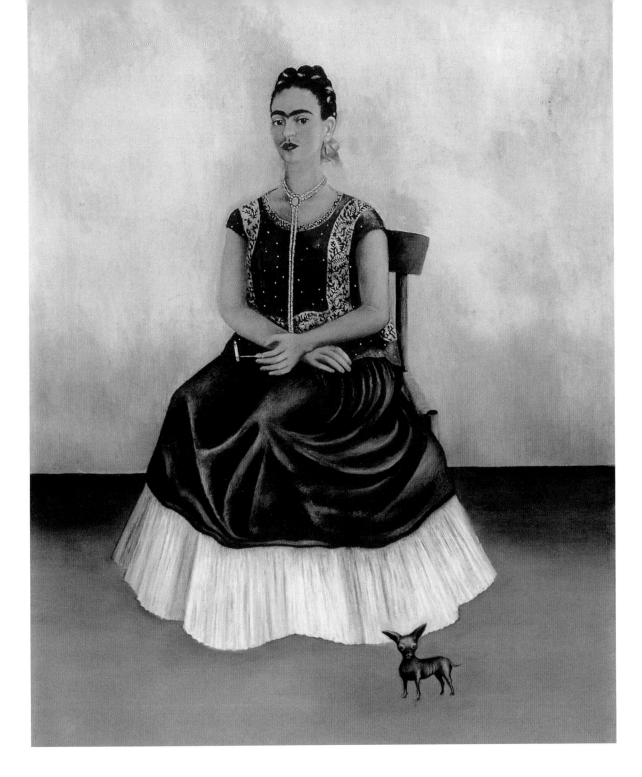

Gray day Frida sits proudly on a chair, yet her bearing cannot divert our attention from the painting's oppressive atmosphere. The room is gray and bare, and Frida's black dress was the type used by Tijuana women when they were bereaved. When Frida painted this self-portrait, she was enjoying success as an artist, yet her exhibitions meant she had to spend long periods away from Diego.

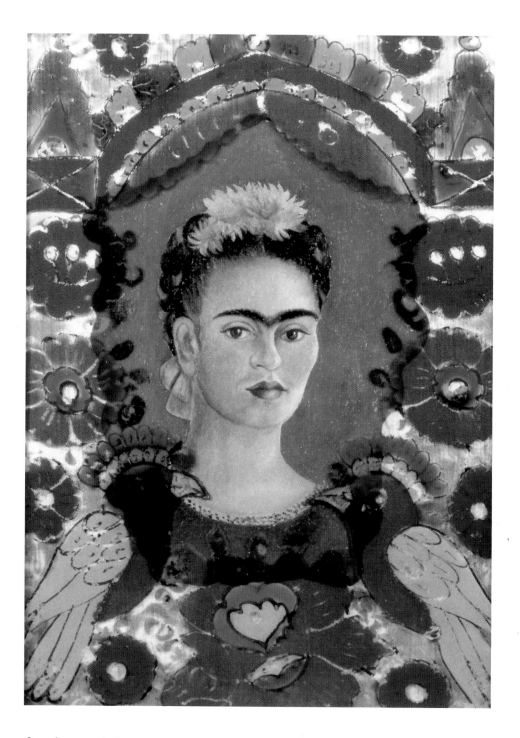

Growing reputation Frida showed this self-portrait as part of an exhibition of Mexican art at Pierre Colle's gallery in Paris. The Louvre purchased it, making Frida the first Latin-American woman artist to have her work represented in the famous museum's collection.

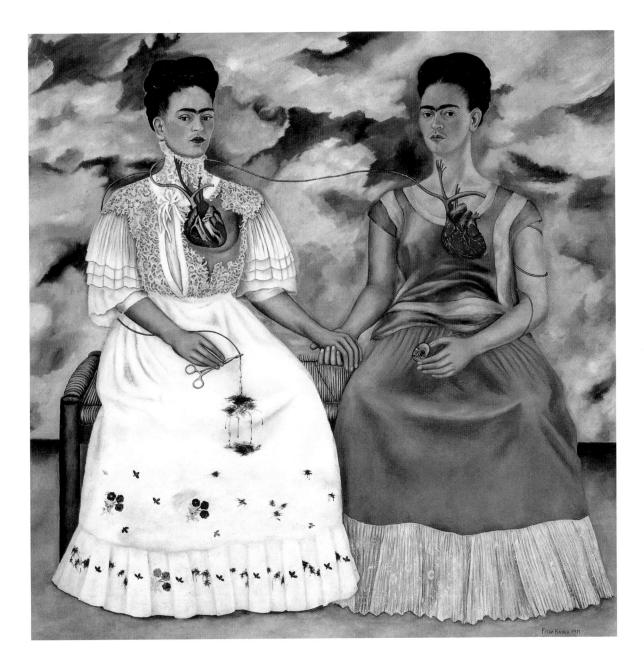

Pain of separation Frida and Diego divorced in 1939. Frida suffered terribly from the separation and used her paintings to transmute her pain into art. This painting of *The Two Fridas*, their hearts exposed and vulnerable, is one of her masterpieces. The Frida on the right holds a medallion with an image of a young Diego that is connected to an artery leading to her heart; the Frida on the left has cut her artery.

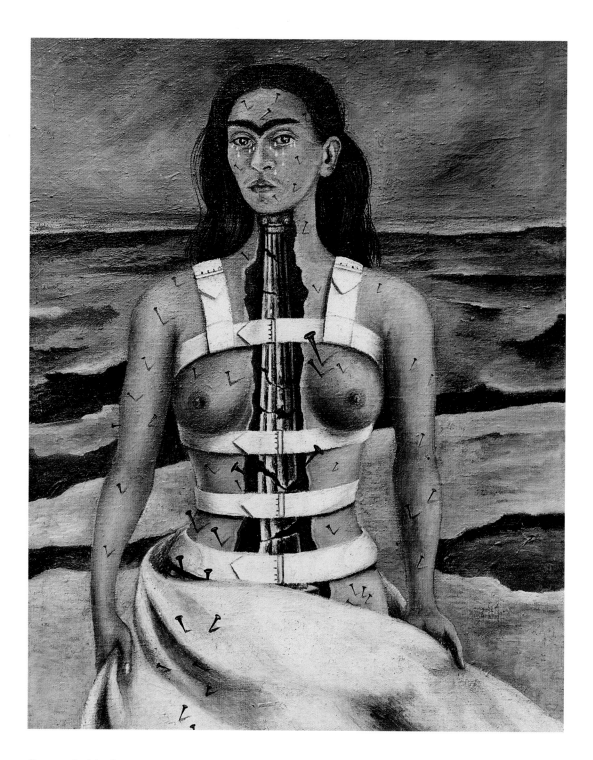

Tormented body Frida failed to recover from the severe bus accident she was involved in when she was eighteen, and often had to wear orthopedic supports. Here her body is split apart, exposing a broken column in place of a spine. Countless nails pierce her bare skin, symbols of her never-ending pain.

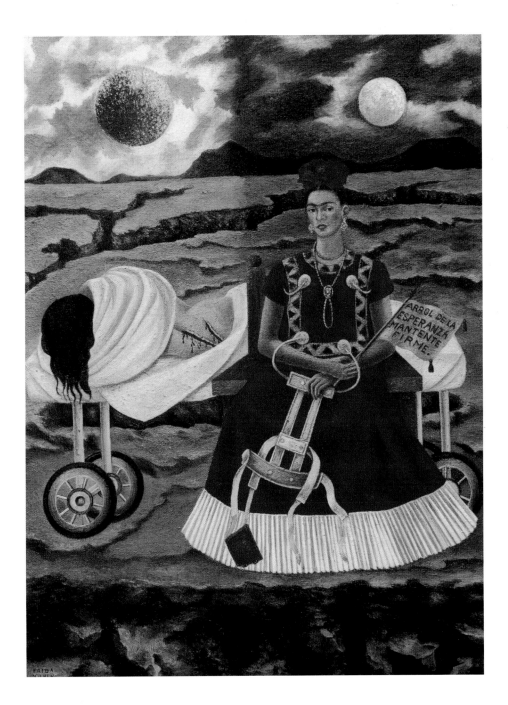

Courage Frida underwent another major back operation in 1946. The treatments she had to endure throughout her life usually brought only temporary relief. Her motto is seen on the flag held by Frida on the right: *Tree of Hope, Keep Strong*.

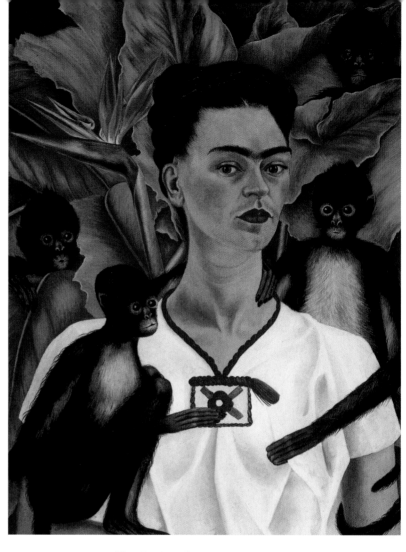

Frida became a teacher at the School of Art in Mexico City in 1943. With a twinkle in her eye, she painted her four students as four monkeys gathered around their proud teacher.

A fresh start

A hard time awaited Frida back in Mexico when Diego divorced her. Their separation was only a short one, however: they remarried barely a year later. Their fresh start brought changes to their living arrangements. Leaving San Angel, Frida and Diego moved into her family home, the Blue House; Guillermo Kahlo had died in 1941. Frida's physical torment continued: "... this thing of feeling such a wreck from head to toe sometimes ravages my brain and makes me have bitter moments."

Despite her poor health, Frida was still productive. In 1943, she was given teaching duties at the new School of Art in Mexico City. Frida's teaching was unconventional, and she quickly won over a group of enthusiastic students. When she was too ill to make the long journey from the Blue House into the city, her most devoted students traveled out to her. Frida affectionately nicknamed these four loyal students 'Los Fridos.'

The Broken Column

Frida's health deteriorated progressively. She had to spend a lot of time lying on her back and had to wear an orthopedic brace. *The Broken Column* is a cry of pain. Forced into a supportive brace, her body is split open, her spine – the column – shattered. Her naked body is pierced by countless nails – they allude not only to her constant physical pain, but also to the love-anguish that Diego's numerous affairs continued to cause her.

In 1946, Frida again traveled to New York to undergo major surgery on her spine. The relief it provided was merely temporary, however, and on her doctor's orders she still had to wear a rigid brace. She was able to paint for only a few hours a day. To prevent her illness from

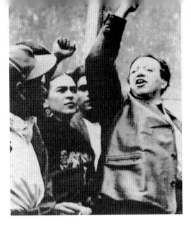

In the last years of her life, Frida devoted a great deal of energy to her political activities. In 1948, she was even re-admitted to the Communist Party from which she had resigned in 1929. She is seen here with Diego at a rally.

dominating her life totally, Frida took powerful painkillers. More and more, she took them with alcohol. *Tree of Hope, Keep Strong*, her motto around this difficult time, shows two Fridas: the one on the left, lying on the operating table, still has bleeding wounds; on the right, the other Frida wears a splendid Tijuana costume and holds her brace in one hand. In her other hand she holds a flag bearing her motto that lends the painting its name. Besides painting, Frida's commitment to politics took up more and more of her time. In 1948, she was re-admitted to the Communist Party.

A difficult year

In 1950, Frida was operated on several times in Mexico City. Her sister Matilde was inconsolable: "She has been through a real Calvary and I don't know how this thing will go ... Her intestines became paralyzed, she has had a temperature of over 39 degrees every day ... constant vomiting and constant pains in her spine, and when the corset was put on her body and she lay on the place where the incision was ... I noticed that a very bad odor was coming from her back ... they opened up the corset and they found an abscess or tumor, all infected, in the wound, and they had to operate on her once more."

Frida spent almost all of 1950 in hospital, and Diego took great care of her. Her poor health did not stop him from continuing to have extramarital affairs, however. Apparently it made no impression on him that there appeared to be a connection between his amorous escapades and Frida's serious relapses.

Back in the Blue House, Frida continued to need care. Most of the time she was confined to bed or her wheelchair, and she continued to consume a potent mix of alcohol and medication. She painted when she felt strong enough, but her physical decline left its mark on her paintings, some of which appear hurried and roughly painted.

The death of a star

Frida was no longer able to recover from her serious

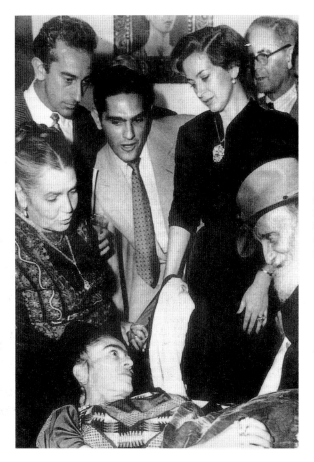

Frida was ill on the day of her first solo exhibition in Mexico. She was taken to the gallery by ambulance and carried in on a stretcher. The day was nevertheless one of the most important in her life.

operations. At home, she surrounded herself solely with her closest friends and her sister Cristina who, together with a specially hired nurse, was at her side night and day. Diego became increasingly unpredictable: he would devote a great deal of attention to her one day, then turn from her abruptly the next. Frida made a number of suicide attempts.

One last ray of hope appeared on the horizon in 1953, when Frida held her first solo exhibition in Mexico. The venue was the Galeria de Arte Contemporáneo, which belonged to her friend Lola Alvarez Bravo. Frida's poor health was no secret, and she was ill the day her show opened. With great foresight, her four-poster bed had

been taken from the Blue House to the gallery, where it was installed among her paintings. The gallery was bursting with expectant visitors when Frida made her entrance. She had been brought to the gallery by ambulance, was carried inside on a stretcher and placed on her bed, from where she held court. She was now at the long desired peak of her career. Diego later recalled: "I thought afterwards that she must have realized she was bidding good-bye to life."

The exhibition caused a stir far beyond Mexico and Frida received congratulations from all over the world. Any newly found optimism was marred by a relapse, however: Frida was now suffering from gangrene. Her doctors saw no alternative other than amputating her lower leg: "It is certain that they are going to amputate my right leg. I know few details, but the opinions are very serious. Dr Luis Méndez and Dr Juan Farill. I am very worried, but at the same time I feel that it will be a liberation."

But it was no liberation. Frida certainly learned to walk with an artificial limb, but her optimism began gradually

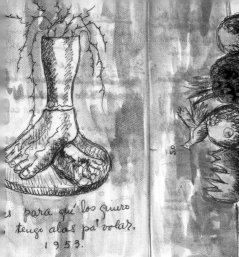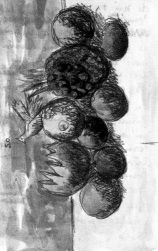

Before her foot was amputated, Frida noted in her diary: "Feet, what do I want them for if I have wings to fly" (above).

Sitting in a wheelchair, Frida joined in a demonstration only days before her death (right).

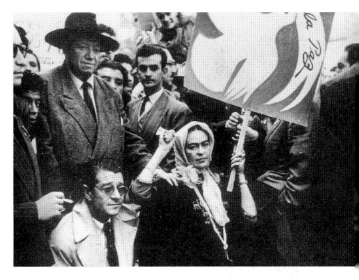

to wane: "They amputated my leg six months ago, they have given me centuries of torture and at moments I almost lost my 'reason.' I keep on wanting to kill myself. Diego is the one who holds me back, because of my vanity in thinking that he would miss me. He has told me so, and I believe him. But never in my life have I suffered more. I will wait a little while longer."

Shortly before Frida's death, her visitors saw a heart-breaking sight: "In her last days she was lying down, unable to move. She was all eyes … Her character was totally changed. She fought with everyone … She was very impatient because she couldn't do things by herself. All she could do was comb her hair and put on lipstick. At the end of her life, when she used makeup she could no longer control her colors. It was grotesque. She was a horrible imitation of the old Frida Kahlo."

Disobeying doctor's orders, Frida, together with Diego, took part in a rally to express solidarity with Guatemala's left-wing president, Jacobo Arbenz, on 2 July

1954. It was to be her last public appearance. After celebrating her birthday with a hundred guests on the 6 July, a bout of protracted pneumonia worsened. Frida died on 13 July. Officially, the cause of death was pulmonary embolism, yet to this day rumors abound that she might have taken an overdose of drugs. Diego kept a vigil by her body as it lay in state in the Palace of Fine Arts. By noon on 14 July, more than six hundred people had paid their last respects to Frida. Before her death, Frida had asked to be cremated. The thought of going to her grave lying down was intolerable to her, as this was the very position that had caused her so much pain in her life. Her ashes now rest in a pre-Columbian urn in a place where she felt truly at home: the Blue House in Coyoacán.

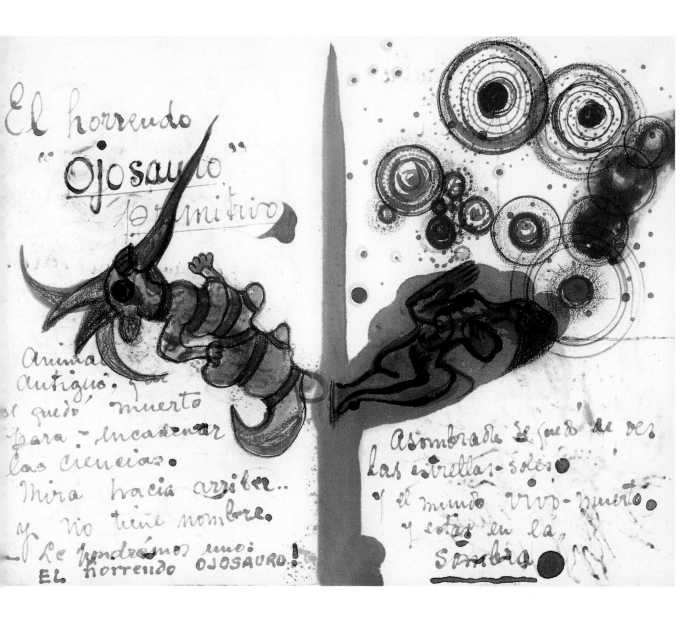

El horrendo "Ojosauro" primitivo

Animal antiguo, que
se quedó muerto
para - Encadenar
las ciencias.
Mira hacia arriba...
y no tiene nombre.
— Le pondremos uno:
EL horrendo OJOSAURO!

Asombrado se quedó de ver
las estrellas-soles.
y el mundo vivo-muerto.
y estas en la
SOMBRA

Recording her feelings Somewhat late in life, Frida began to keep a diary. In it, she not only commented on her experiences, but also expressed her innermost thoughts and feelings in often rather cryptic drawings, watercolors, and poems. Here a reclining woman looking at the starry sky, and a fantasy creature she called the "horrible *ojosauro*" (a word she invented) are purely the products of her imagination.

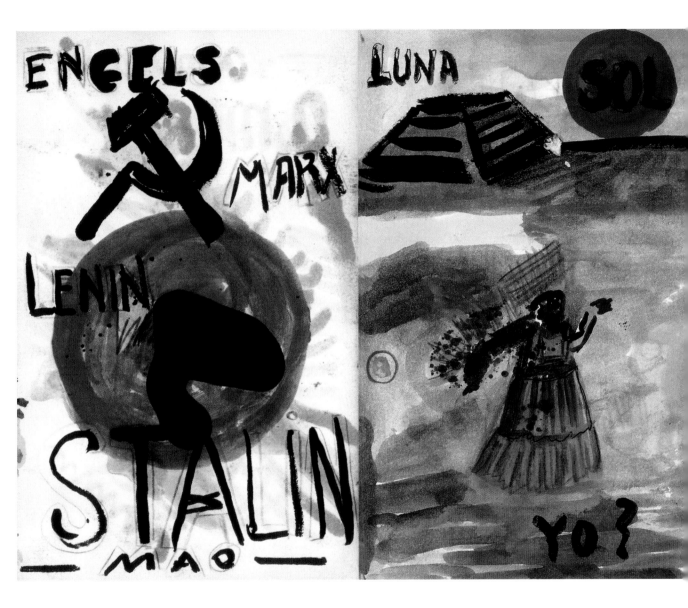

Her all for the party "I have to fight with all my strength to contribute the few positive things my health allows me to the revolution. The only true reason for which to live." These lines in Frida's diary testify to the extent Communism shaped her thoughts: Engels, Marx, Stalin, and Mao were now her 'saviors.'

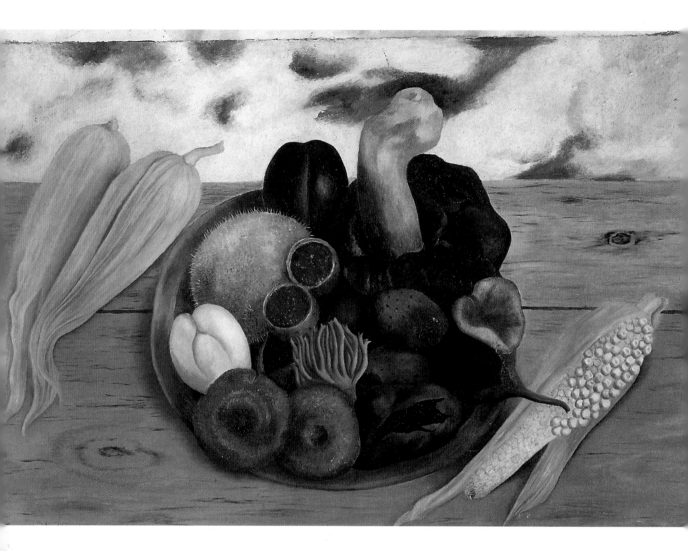

Fruits of the earth Frida also painted a number of still-lifes that are not merely representations of flowers or fruit. They also conceal deeper meanings. Against a background of a gloomy, overcast sky, the red flesh of the fruit recalls her ravaged body on the one hand, while on the other the fruit and vegetables themselves have erotic associations.

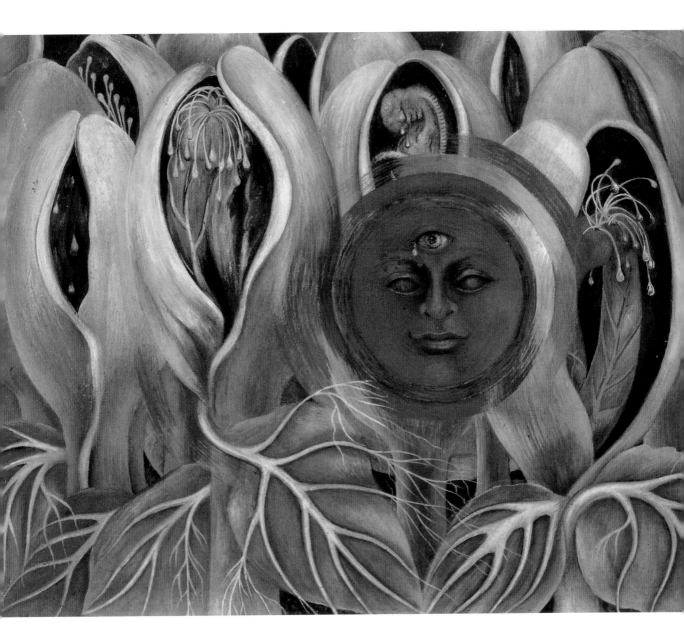

Suggestive foliage Only at first glance does *Sun and Life* appear to be a plant picture. A second glance reveals its sexualized forms. Immediately behind the life-giving sun, there is a bud contains a weeping embryo, a symbol of Frida's unfulfilled desire for a child.

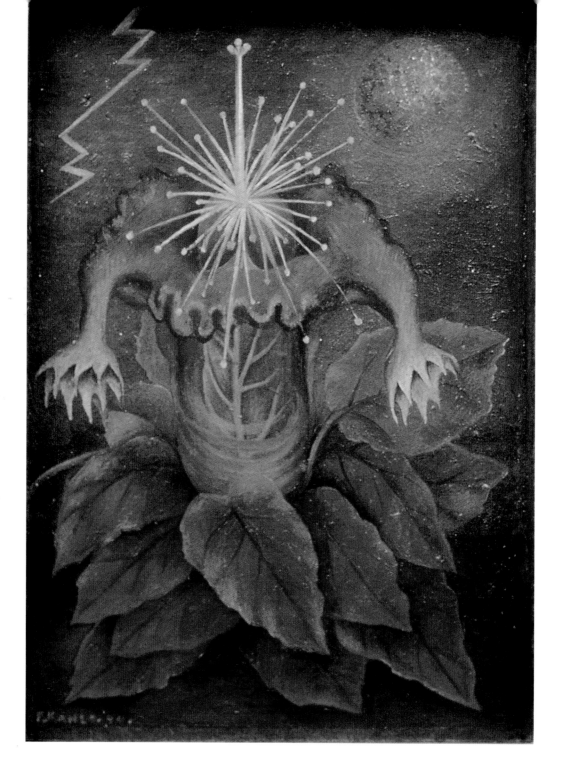

Flower of life Painted by Frida in 1944, this exotic 'flower painting' is a homage to physical love and the mystery of reproduction.

The rage for life An unusually expressive work, *The Circle*, which Frida painted just three years before her death, is a frank affirmation of her sexuality. At the same time, it is also a raw expression of her despair over her continuing physical decline.

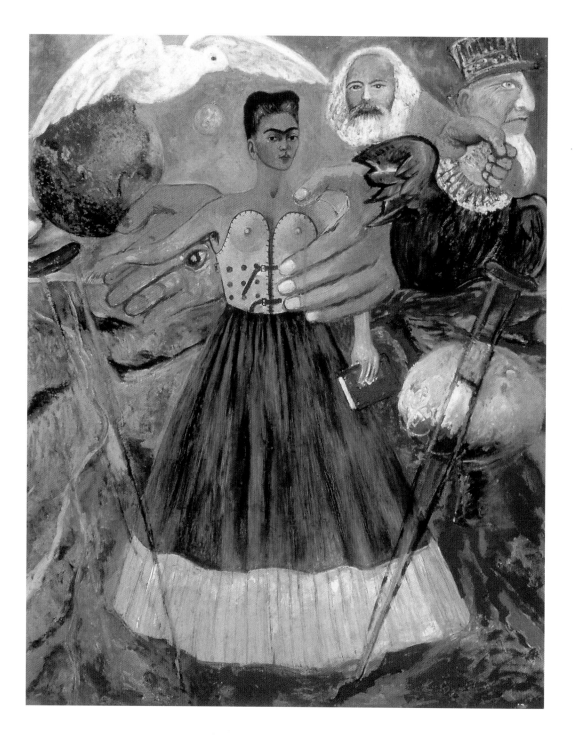

Utopia Towards the end of her life, Frida's glorification of Communism took on strange forms. She hoped her 'political gods' would give her release from her physical suffering. In *Marxism Will Give Health to the Sick*, which she painted the year she died, Frida casts her crutches aside and stands tall and upright in the center of the picture.

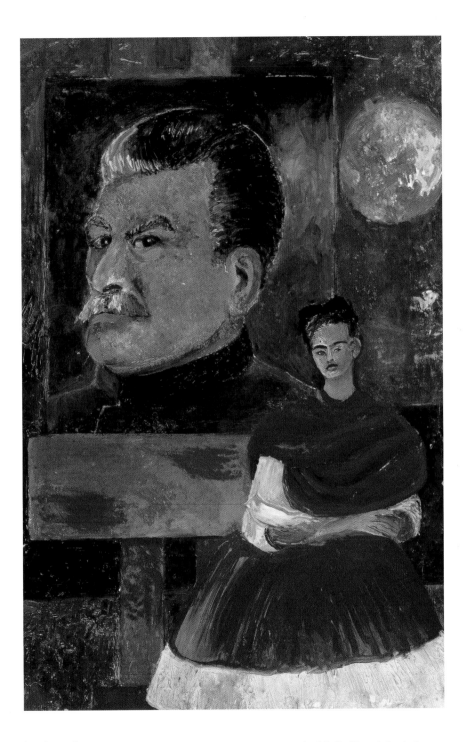

Last works A proud Frida is seated in front of an oversize portrait of Stalin. The painting looks hurried, edgy, almost crude. To deaden her constant pain, Frida numbed her body with a mixture of drink and medication, which in itself had serious consequences for her health and her art.

"If I loved a woman, the more I loved her, the more I wanted to hurt her. Frida was only the most obvious victim of this despicable trait."

Diego Rivera, autobiography

Fiery passion ...

... was characteristic of Frida's *biographie amoureuse*. And it was not only her fellow artists who fell under her spell, but also the Russian revolutionary Leon Trotsky. But the great love of her life – Diego Rivera – was also the cause of her deepest pain, for he was an incorrigible playboy who was unfaithful to Frida to the last.

Till death us do part

In 1929, Frida married the celebrated artist Diego Rivera, who was more than twenty years her senior. Unable to be faithful, he lived up to his reputation as a philanderer, yet his love for Frida endured. Their divorce in 1939 had barely come into force when they married for a second time. Frida took a pragmatic line: "Diego is not anybody's husband and never will be, but he is a great *comrade*." Despite many bitter setbacks, their renewed ties did indeed last until her death.

Frida and Diego as newlyweds.

Frida loved passionately ...

-→ **Alejandro Gómez Arias, her first lover, who left her after her accident.**

-→ **and later the photographer Nickolas Muray, whose beautifully sensuous photographs of her speak volumes.**

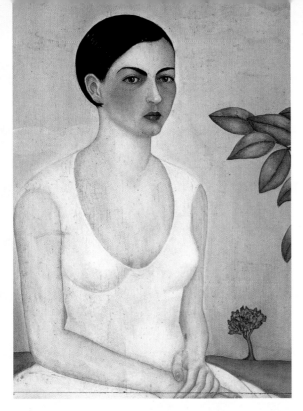

Betrayal

After her own marriage failed, Cristina Kahlo spent a great deal of time with her sister and Diego. Frida soon discovered that the relationship between Diego and Cristina was far from platonic – they were having an affair. In utter despair, Frida moved out of the marital home into her own apartment, and tried to overcome her pain by having numerous amorous adventures of her own. Although Cristina's betrayal broke her heart, Frida was later reconciled to her sister and returned to Diego.

The lure of the East

Frida was greatly attracted to the Japanese sculptor Isamu Noguchi, who lived in Mexico for some time. She spent man happy days in his company, and even had a serious affair with him. Diego, himself King of Womanizers, brought it to a violent end. Brandishing his gun at his Japanese rival, he threatened to shoot him if he ever saw him again.

'Little Goatee'

In 1937, the Russian revolutionary Leon Trotsky had to leave Europe for Mexico. Frida became his special hostess: very soon, he came to share both her table and her bed. The affair between Frida and her 'Little Goatee' was short-lived, however. Diego was more important to her, and Trotsky, too, stuck by his wife, Natalia. On leaving the Blue House, the Russian moved into another house in the district. He was murdered there three years later.

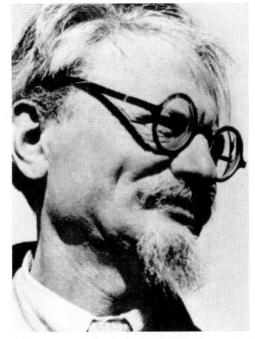

Frida and women

Even Diego recognized that two women could have "a much more extraordinary experience." This explains why he was harsh when it came to putting his male rivals in their place, but tended to take a benevolent view of Frida's lesbian lovers, of whom Frida had more than one. Unlike many of her affairs with men, her experiences with women were short-lived and were generally limited to passionate one-night stands.

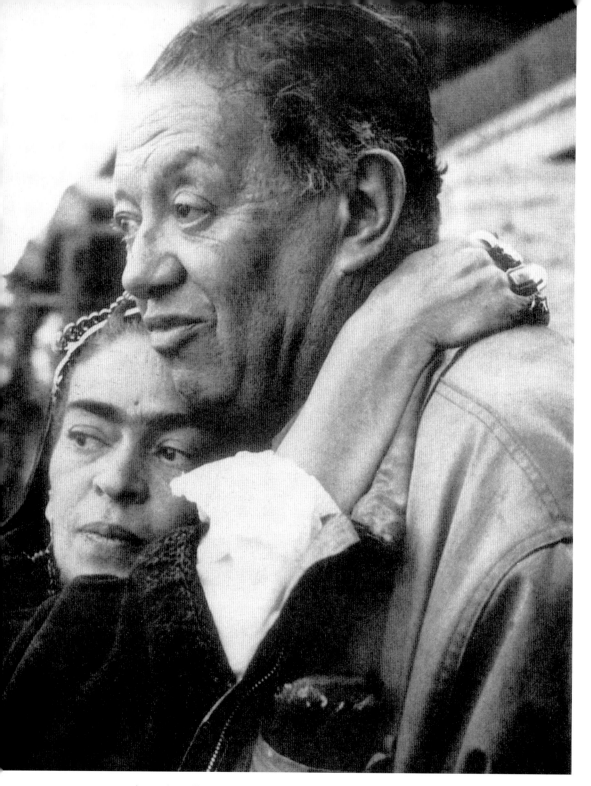

Love to last a lifetime. Despite tragedies and acrimonious quarrels, Frida and Diego were always reconciled and stayed together to the last. This photograph was taken in 1954, shortly before Frida's death.

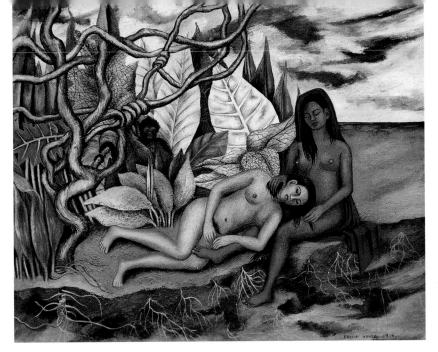

Frida made no secret of the fact that she was attracted to her own sex. *Two Nudes in the Wood* was painted for her friend Dolores del Rio.

The Elephant and the Dove

Did the 20th century see more glittering, passionate and exciting husband-and-wife artists than Diego Rivera and Frida Kahlo? The liaison between the 'Elephant' and the 'Dove' is unquestionably one of the great tales of love and suffering in modern times.

First love

Frida saw the famous painter Diego Rivera for the first time when she was still a teenager. She was a pupil at the National Preparatory School, where Diego was working on a mural in the school's assembly hall. It was something of a sensation for the pupils to see the legendary artist working on his scaffold every day.

> "I suffered two grave accidents in my life. One was when a streetcar knocked me down … The other was Diego."
>
> **Frida Kahlo**

Frida often observed him at work, yet showed him little respect. Her gang was more concerned with playing tricks on figures of authority, and with making their dull lessons a bit more entertaining. Diego was also one of the gang's victims, becoming the beneficiary of derisive nicknames such as 'Old Fatso.' He later recalled that his then wife, Lupe Marín, instinctively recognized Frida as a rival: "In time, she aroused Lupe's jealousy, and Lupe

Diego was working on his mural of *The Creation* in the 'Prepa' when Frida, who was still attending the school, first saw him. Rather than worship him, she and her friends played tricks on him.

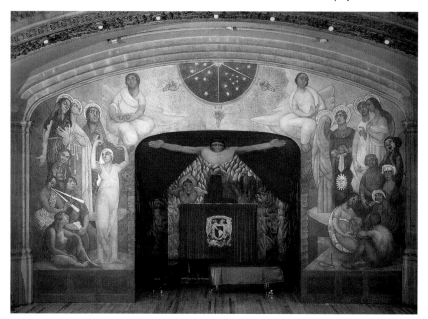

began to swear at Frida, who paid not the slightest attention to her. This just made Lupe more and more enraged."

Lupe's jealousy was unfounded, however, for at this point Frida had eyes only for Alejandro Gómez Arias. A few years older than she was, he was eloquent and cultured – and he became Frida's first boyfriend. Her letters to him tell of her feelings: "My Alex: Since I first saw you I have loved you ... Because it will probably be a few days before we see each other, I'm going to beg you not to forget your pretty little girl ... Alex, write to me soon and ... tell me that you love me very much and that you can't live without me ..." It was with Alejandro that Frida discovered physical love. He later recalled: "To her, sex was a form of enjoying life, a kind of vital impulse."

Frida's serious accident marked the beginning of the end of her first love affair. Frida was encased in plaster and confined to bed. Alejandro's visits became less and less frequent. "Shake yourself and come and visit me! I can't believe you've turned a deaf ear now when I need you so much." In 1927, Alejandro left for an extended tour of Europe, plunging Frida into a crisis. The relationship came to an end a year later when Alejandro fell in love with someone else. Frida: "Now as never before I feel that you do not love me any more ... Deep down, you understand ... that you are not only a thing that is mine, but you are me myself! Irreplaceable!"

Something clicked

We will probably never know how and when Frida and Diego met. Later they both gave different accounts of their first meeting, but one of Frida's versions is probably the most accurate: "As soon as they allowed me back to school, I tucked my work under my arm and set off to see Diego Rivera, who was then working on a mural in the Ministry of Education. I still hadn't met him

Before Diego met Frida and fell in love with her, he was married to Lupe Marín (left).

Despite his unconventional appearance, which he captured in several self-portraits (below), Diego easily won women's hearts.

personally at this point, but I admired him beyond measure. I was bold enough to ask him to come down from his scaffold and to ask him his opinion of my paintings ... and his verdict was that I was talented."

Diego was twenty-one years older than Frida, and was at the point of separating from Lupe Marín. His success with women is rather curious because he was corpulent, had bulging eyes, and made little effort to impress with his appearance. His hair was usually unwashed, his clothes untidy. His aura of unequalled artistic genius, combined with his incredible charm and sense of humor, easily outshone his evident shortcomings, however. His reputation as a womanizer was legendary, and his marriage to Lupe failed not least because of his numerous affairs.

Frida stood out from his crowd of admirers. Diego recalled the first time he met her: "I didn't know it then, but Frida had already become the most important thing in my life. And she would continue to be, up to the moment she died, twenty-seven years later." The signatures on the papers divorcing him from Lupe were hard-

ly dry when Diego asked for Frida's hand in marriage. They married on 21 August 1929.

Guillermo Kahlo and his wife Matilde were far from enthusiastic about the marriage: "... my parents did not like this because Diego was a Communist, and because they said he looked like a fat, fat Brueghel. They said that it was like marriage between an elephant and a dove."

Lupe, too, had her problems with the newly weds. At the wedding reception, late at night, she lifted Frida's skirt and cried: "Do you see these two sticks? That's what

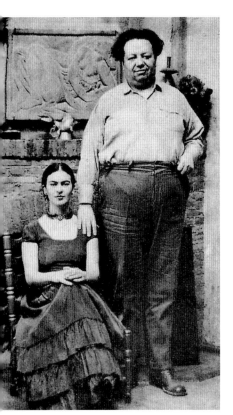

Frida's mother called the odd couple "the Elephant and the Dove." The comparison could not be more fitting.

Diego's going to have to put up with from now on, and before he used to have my legs!" What a way to start life together!

An unfulfilled wish

Diego is reputed to have had his first affairs shortly after marrying Frida. Even the two miscarriages she suffered in the early years of their marriage did not curb his philandering, though he did look after his ill and depressed wife well. Many of Frida's paintings reveal her longing for children, and the fact that she remained childless was not due simply to health problems. She knew that more children were not important to Diego, who already had offspring from previous relationships: "I do not think that Diego would be very interested in having a child since what preoccupies him most is his work, and he is absolutely right. Children would take fourth place."

It is not known for certain how many miscarriages Frida suffered. The conflict between Diego's indifference and her own longing for children is possibly the reason why she could never fully accept her pregnancies. She ignored doctor's orders, missed examinations, and didn't rest.

Her paintings are not the only expression of her need for a child, however. Her collection of dolls, her great love of animals, and the important role she played in the life of her niece and nephew are all evidence of the same yearning.

A cruel betrayal

When Diego received a number of commissions in the United States, Frida went with him. It was an exciting time, but Frida was homesick. When Diego finally relented and returned to Mexico with her, he became dejected. Frida felt helpless: "... he thinks that everything that is happening to him is my fault, because I made him come home to Mexico ... and that's why he's the way he is. I do everything possible to encourage him, and to

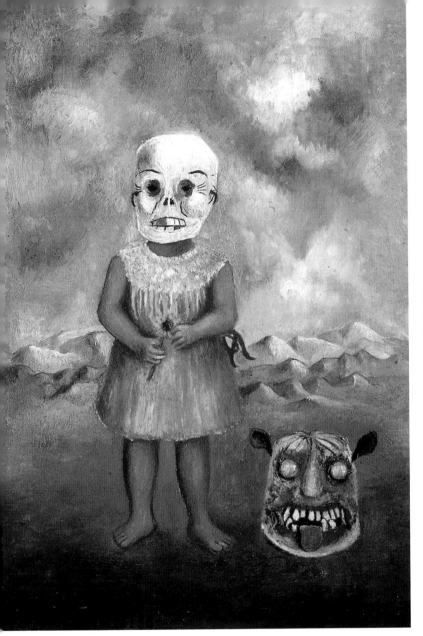

Here Frida has captured on canvas her fears and guilt about the children she miscarried. With her face concealed behind a death mask, a girl stands amid the bleak landscape of the Mexican Plateau.

affair. When Frida discovered their betrayal, her world collapsed around her. She and Diego could not patch up their differences this time: "The situation with Diego grows worse each day. I know that much of the fault for what has happened has been mine because I didn't understand what he wanted from the beginning, and because I opposed something that could no longer be helped. Now, after many months of real torment for me, I forgave my sister and I thought that with this, things would change a little, but it was just the opposite ... I know that Diego is for the moment more interested in her than in me, and I should understand that it is not his fault, and that I am the one who should compromise if I want him to be happy. But it costs me so much to go through this ..."

Around this time, Diego was working on a cycle of frescoes in the National Palace in Mexico City. How much

arrange things in a way that is easier for him, but I have still not succeeded in anything ..."

Frida's favorite sister Cristina was also going through a difficult time. Her marriage had been ill-starred from the start and now broke down completely. With her two children, she moved back into the Blue House, her parents' home. She also spent long days in San Angel, where Diego had had a house built for himself and Frida. Things went badly. Diego and Cristina started an

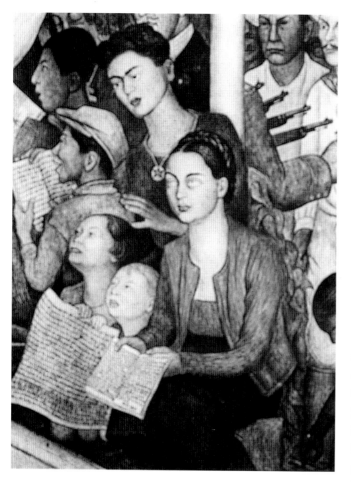

hurt must it have caused Frida to see the section of it entitled *Mexico Today and Tomorrow*? Portrayed as a beautiful woman, Cristina sits upon a pedestal next to her two children. Half concealed behind her stands Frida, a tired shadow of herself compared with her radiant sister. Diego's recognition of the disaster for which he was responsible seems almost cynical: "If I loved a woman, the more I loved her, the more I wanted to hurt her. Frida was only the most obvious victim of this despicable trait."

Tit for tat

When she discovered the affair between Cristina and Diego, Frida packed her things and moved into a apartment of her own, where she turned her anger and despair against herself. Faced with such a disaster, she expressed her pain directly in her paintings. Frida's most drastic means of expression became the bleeding heart, an image clearly linked to the form of human sacrifice her Aztec forebears had offered up to their gods.

When she began to feel too lonely in Mexico City, she traveled to New York, where she threw herself into numerous affairs that were intended to bolster her battered self-confidence. Never having made a secret of her bisexuality, Frida took both men and women as her lovers. In younger years, she was fond of dressing as a tomboy, while male characteristics such as her downy moustache and meeting eyebrows are hard to overlook in her self-portraits. Interestingly, Diego seems to have derived some pleasure from Frida's lesbian affairs: "Men's sexual organ is in just one place … Women's, on the other hand, is all over the body, and therefore two women together will have a much more extraordinary experience."

When the Japanese sculptor Isamu Noguchi had an affair with Frida, Diego was so jealous that he finally threatened his rival with a pistol.

While Diego did not view women as sexual rivals, he exploded with jealousy when Frida had an intense affair with the Japanese sculptor Isamu Noguchi. He later recalled: "I loved her very much. She was a lovely person, an absolutely marvelous person ... I knew Frida well during an eight-month period. We went dancing all the time. Frida loved to dance. That was her real passion, you know ..." The end of their affair was dramatic, if Noguchi is to be believed. It was the last straw for Diego when he discovered his rival with Frida on several occasions: "Diego showed me his gun and said 'Next time I see you, I'm going to shoot you!'"

After a brief separation, Frida and Diego got together again: "... at bottom you and I love each other dearly, and thus go through endless adventures, beatings on doors, curses, insults ... – yet we will always love each other ... I shall always hope that that continues, and with that I am content."

Revolutionary charm

Once Diego had pulled strings in the government, Leon Trotsky was granted asylum in Mexico in 1937. Frida was devoted in her attention to the charismatic revolutionary, and it was not long before he succumbed to her charms. Love letters were slipped into warmly recommended books that were exchanged in front of Trotsky's wife. Having moved into a home of her own, Cristina made rooms available for lovers' trysts.

Frida's legendary affair with Trotsky ended quickly and unspectacularly. Both agreed they did not wish to risk their marriages, and parted amicably. A painting pro-

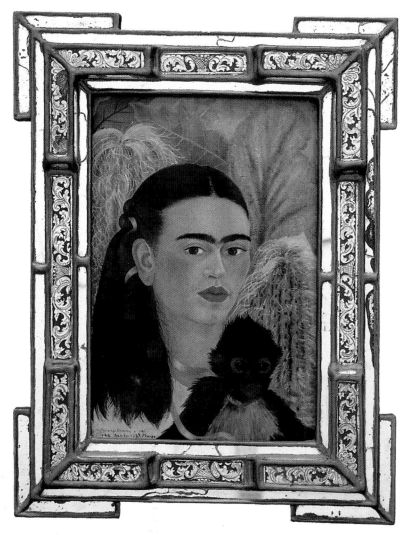

Frida produced this painting the year she met Leon Trotsky. With its phallic cacti and its monkey, a symbol of lust, it has an aura of subtle eroticism.

long lived in the United States. Frida fell for "adorable Nick," whose stunning photographs of her are more beautiful and expressive than any declaration of love.

After New York, Frida went on to Paris for another exhibition. Passionate letters convey her longing for him: "... your telegram arrived this morning, and I cried very much – tears of happiness, and because I miss you with all my heart and my blood. Your letter, my sweet, came yesterday, it's so beautiful, so tender, that I have no words to tell you what a joy it gave me ... For you, my heart full of tenderness and caresses. One special kiss on you neck."

duced by Frida that year clearly shows how the affair gave her a boost: *Fulang Chang and I* (above) is rich in subliminal eroticism, both in the form the phallic cacti behind Frida and the monkey Fulang Chang, one of her pets, which symbolizes lust.

Adorable Nick

Frida enjoyed great success in 1938 when the first solo exhibition of her work was shown in New York. Just as exciting as her artistic success was her relationship with Nickolas Muray, a Hungarian-born photographer who had

Despite the great passion that her lines to Nick convey, Frida in her heart of hearts remained completely captivated by Diego. In a letter to Nick she wrote: "I adore you my love, believe me, like I never loved anyone – only Diego will

Frida looks beautiful in
this portrait photograph
taken by Nickolas Muray
during their affair.

be in my heart as close as you – always ..." Is this why Nick
brought the affair to an end? Full of expectation, Frida re-
turned to New York in March 1939 only to be presented
with a fait accompli. Muray wrote to her: "I knew NY only
filled the bill as a temporary substitute ... Of the three of
us there was only two of you. I always felt that."

Everything is over now

To Frida's great sadness, not only her affair with
Nickolas Muray was over; in Mexico she was faced,
once more, with the ruins of her marriage. We do not
know why Frida again moved out of the house in San
Angel. Was it because of Diego's affairs with the at-
tractive actress Pauline Goddard and the painter Irene
Bohus? Diego, too, had had enough of emotional
chaos: "I loved her too much to want to cause her suf-
fering, and to spare her further torments, I decided to
separate from her ... I simply wanted to be free to
carry on with any woman who caught my fancy." He
was not going to change. At his instigation, the divorce
papers were signed on 6 November 1939.

Diego immortalized
Frida as a nude in this
lithograph from 1930.

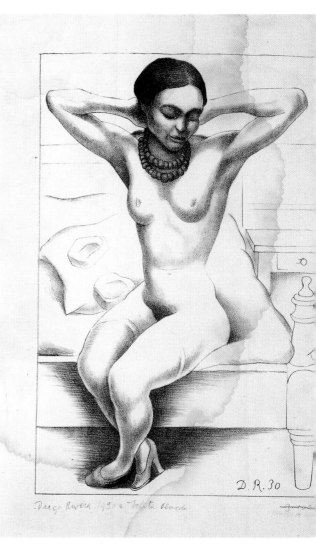

"... my situation with Diego grew worse and worse, till finally it came to an end. Two weeks ago we began the divorce ... I love Diego ... but after the last fight I had with him, by phone, because it's almost a month since I'd seen him, I understood that for him it's much better to leave me. He hurled terrible insults at me, which I didn't expect from him." Frida was deeply hurt, and sought solace in alcohol. As a reaction to her emotional suffering, she became physically ill. Her long hair became a victim of her unhappiness in love: in *Self-Portrait with Cropped Hair*, she holds a pair of scissors in one hand and her chopped-off hair is strewn all around her. She renounces her femininity both by cutting her hair short and by donning a man's suit in place of the Tijuana costume that Diego loved. Despite being divorced, Frida and Diego were still in touch: "Well anyway, I take care of him the best I can from the distance, and I will love him all my life, even if he wouldn't want me to."

A turn for the worse

When Frida's health did not improve, she traveled to San Francisco for an operation with Dr Leo Eloesser. Diego also had to go there to work on a commission. It was around this time that Diego met the art lover Heinz Berggruen; he was twenty-five and had fled to the United States from Nazi Germany. When he was allowed to join the great artist on a visit to Frida's bedside, he was lost the moment he set eyes on her. The fascination appeared to be mutual: no sooner was Frida reasonably fit than she took the young German with her on a two-month visit to New York, where she

Frida scribbled a note to Diego on an envelope and posted it with a kiss: "I love you more than ever. Your girl, Frida."

was preparing an exhibition. Their affair was intense but brief. After their time together in Manhattan, the two never saw each other again.

While Frida was in New York with her very young lover, Leo Eloesser was busy in San Francisco. It was clear to him that a direct link existed between Frida's illnesses and her chaotic relationship with Diego, and he did his best to improve the situation. He not only encouraged Frida to show understanding for her ex-husband's chronic infidelity, he also spoke with Diego himself. And it worked. In San Francisco on 8 December 1940, Diego's birthday, he and Frida married for a second time.

Frida's agreement to re-marry Diego depended on certain conditions: "... she would provide for herself financially from the proceeds of her own work, that I would pay half of our household expenses – nothing more – and that we would have no sexual intercourse. In explaining this last stipulation, she said that, with the images of all my other women flashing through her mind, she couldn't possibly make love to me, for a psychological barrier would spring up as soon as I made advances. I was so happy to have Frida back that I agreed to everything."

It has to be wondered how strictly these conditions were observed.Similar to those traditionally set alight in Mexico at Easter time, an effigy of Judas lies across the top of Frida's four-poster bed in one painting. In her dream, the figure holds a luxuriant bouquet and appears to be both protective and menacing.

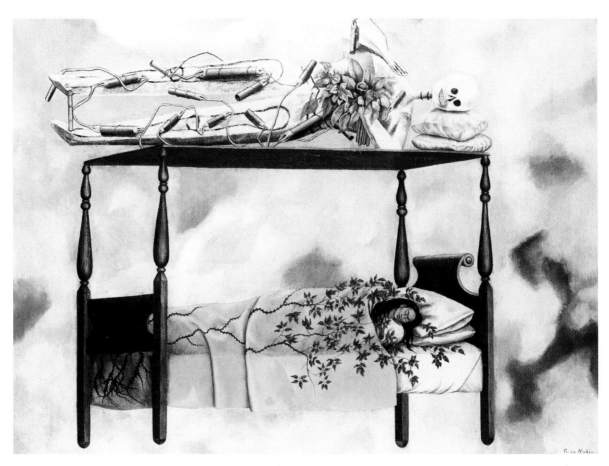

Similar to those traditionally set alight in Mexico at Easter time, an effigy of Judas lies across the top of Frida's four-poster bed. In her dream, the figure holds a luxuriant bouquet and appears to be both protective and menacing.

Diego Universe

With new conditions in place, life together for Frida and Diego at first ran smoothly. Frida wrote to Leo Eloesser: "The remarriage functions well. A few quarrels, better mutual understanding and, on my part, fewer interrogations of the tedious kind with respect to other women." Frida's relationship with Diego as-sumed an unmistakably maternal character. "Every instant, he is my child, my newborn babe, every moment of every day, of my own self," she wrote in her diary, and painted him in *The Love Embrace of the Universe, The Earth (Mexico), I, Diego and Señor Xólotl* (Page 111).

Between 1946 and 1952, Frida and the Spanish émigré artist José Bartolí had a passionate affair that she kept a close secret. Despite her own liaison and air of composure, Frida continued to be troubled by Diego's affairs. He was not merely her husband and imaginary

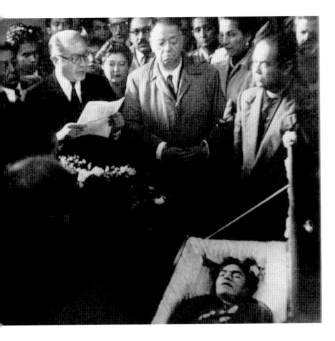

Diego stands grief-stricken beside Frida's open coffin. Her body lay in state in the Palace of Fine Arts, where over six hundred people paid her their last respects.

child; he was her whole life, the center of her world. In a kind of elegy she recorded in her diary, she wrote: "Diego Universe. Why do I call him *my* Diego? He never was or will be mine. He belongs to himself." With the exception of their marriage portrait, Frida never painted herself and Diego together. Now, however, she produced a series of pictures that testified to her desperate love for him. She twice painted her own and Diego's head blended into one, and in *Diego and I* she bears his image on her forehead. Around this time, Frida was interested in the philosophy of Eastern religions, which explains Diego's 'third eye.' It can be assigned to the Indian god Siva, who showed his third eye only when he wanted to destroy. When Frida was working on this painting, Diego openly professed his love for his mistress of the day, the film star Maria Félix.

The farewell

In the mid 1940s, Frida's physical health deteriorated. A long line of major operations came to an end in 1953 with the amputation of her right leg below the knee. Even then, her first thoughts were for Diego: "I hope I will be able, when I am walking, to give all the strength that I have left to Diego. Everything for Diego."

Diego, in contrast, became more and more temperamental. While he stuck by her in her darkest hours, and even moved into the hospital for a while to be beside her, his appetite for other women could not be stilled. With a sense of helplessness, Frida watched as Diego's lover, Emma Hurtado, collected him from the hospital to take him to the opening of an exhibition.

Only three months after her first solo exhibition in Mexico City, Frida Kahlo died on 13 July 1954. Diego later described that day as "the most tragic day of my life. I had lost my beloved Frida, forever ... Too late, now, I realized that the most wonderful part of my life had been my love for Frida." On the first anniversary of her death, he still made a drawing of his "darling Fridita." Sixteen days later, he married Emma Hurtado. Two years later, on 24 November 1957, Diego Rivera died of a heart attack in his San Angel studio.

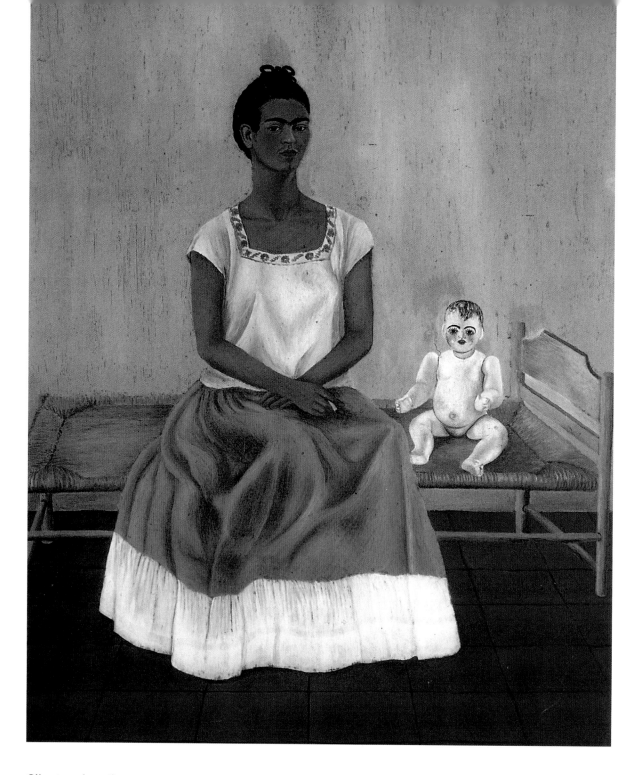

Silent resignation Frida suffered a number of miscarriages, and throughout her life never overcame her unfulfilled longing for children. Diego was hardly a help to her in her despair – he lived for his work, and for him "children would take fourth place." Set in a bare room, the strangely rigid self-portrait *My Doll and I* is an expression of Frida's sense of loss.

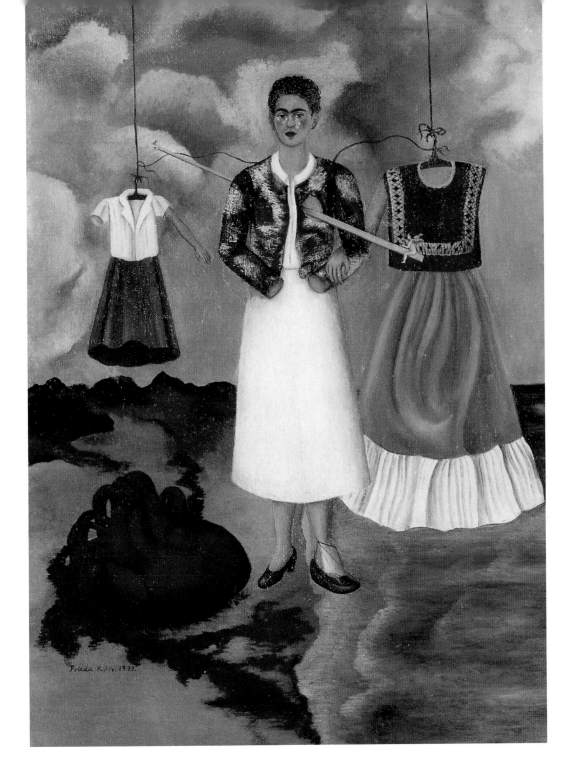

Torments of love The visual imagery in *Memory or The Heart* is unmistakable. Frida expresses her sadness at Diego's affairs by portraying herself with a gaping hole in her chest, while her larger-than-life-sized heart lies bleeding on the ground. The torn-out heart also alludes to the human sacrifices offered by the Aztecs to their gods.

103

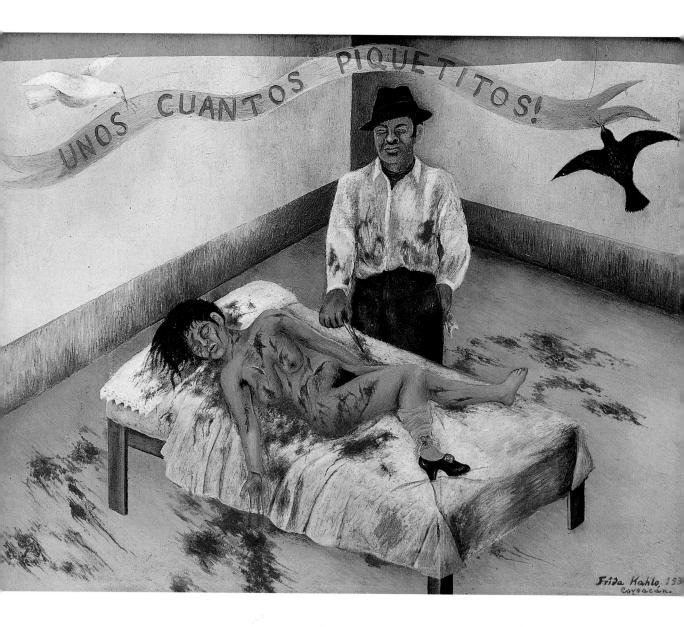

A few little cuts Frida here illustrates a tragedy she had read about in a newspaper. Out of jealousy, a man had stabbed his wife. Before the court, he protested that he had given her "only a few little cuts." Figuratively, she means herself and Diego, who failed to understand the pain his infidelity caused her.

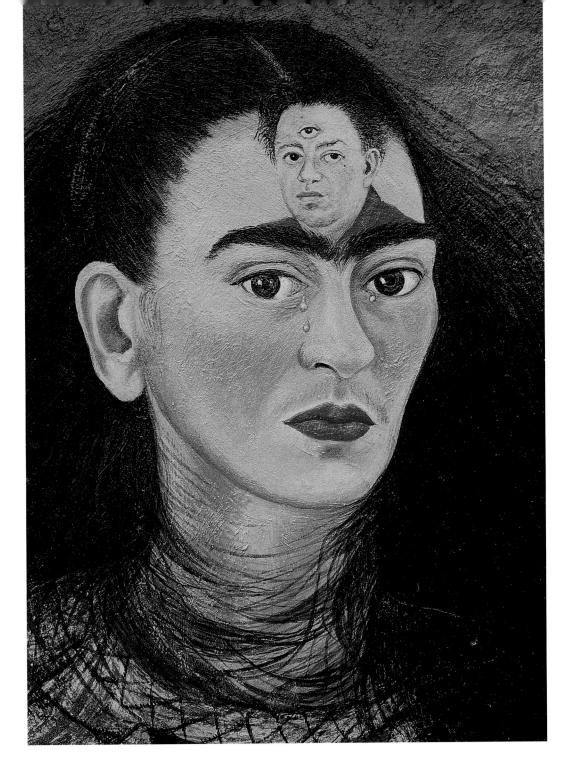

Bitter tears Diego was having an affair with the actress Maria Félix when this painting was created. Its first owners were Florence Arquin and Sam Williams, who knew Frida well. "Seeing Frida sad and crying, with her hair wound around her neck, brought tears to our eyes."

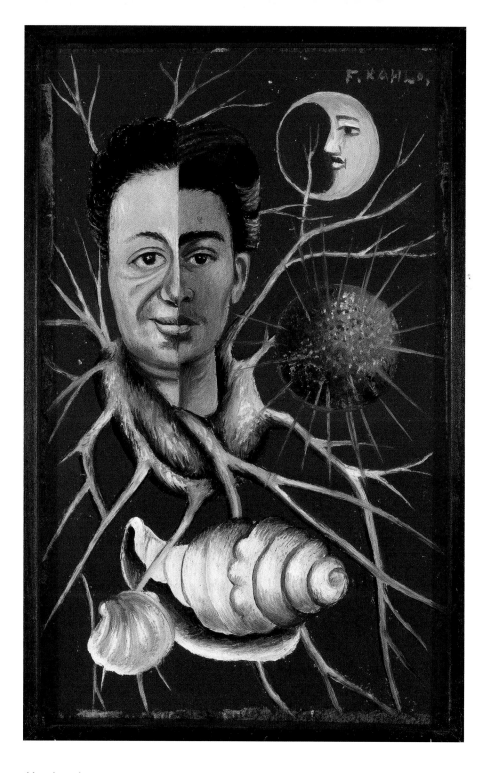

Absolute love Frida presented this painted declaration of her love to Diego on his fifty-eighth birthday. His face and hers merge to form a whole. Dualistic symbols of man and woman, the sun and the moon, hover beside the head of 'Diego-Frida,' which wears a serene expression.

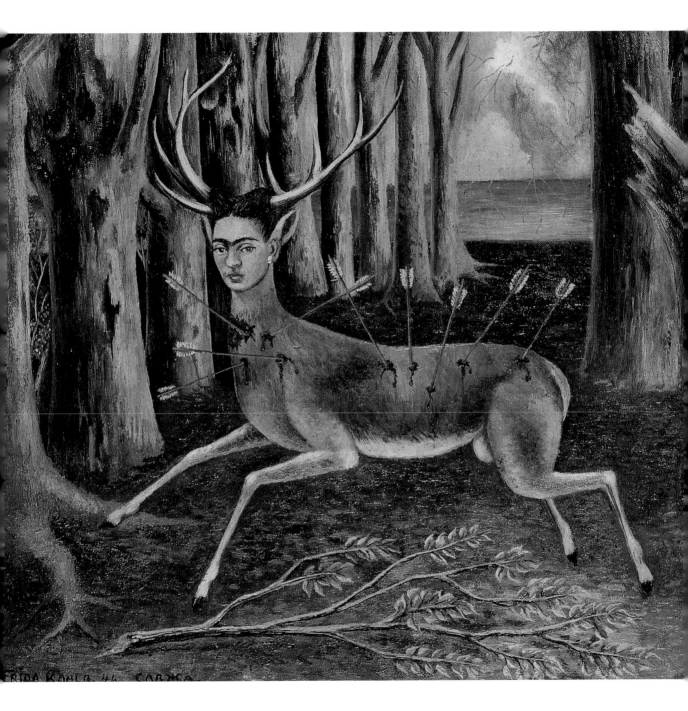

"I'm a poor little deer" Frida viewed herself as a wounded deer, pursued and at the mercy of relentless arrows that symbolize not only her physical pain, but also the mental anguish she felt at Diego's infidelity. The deer's body may be wounded and weakened, but Frida gazes out of the picture with dignity, her splendid antlers proudly raised.

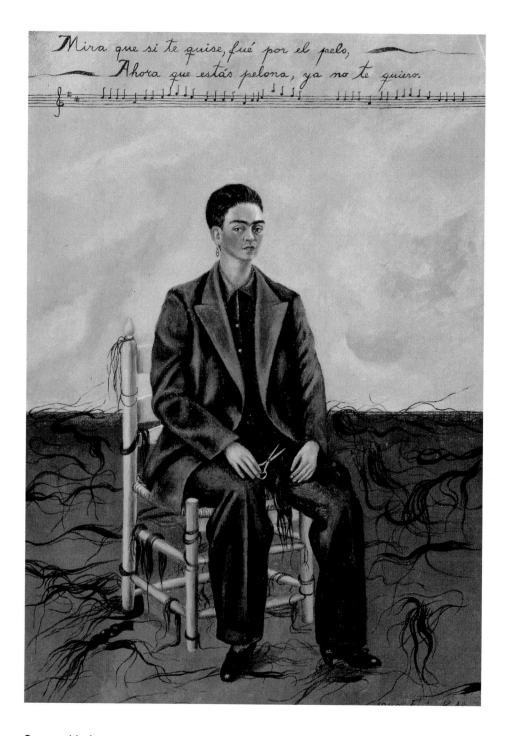

Cropped hair When Diego divorced her, Frida cut off her hair for the second time. The lyrics are from a popular Mexican song: "Look, if I loved you, it was because of your hair. Now you're shorn, I love you no more."

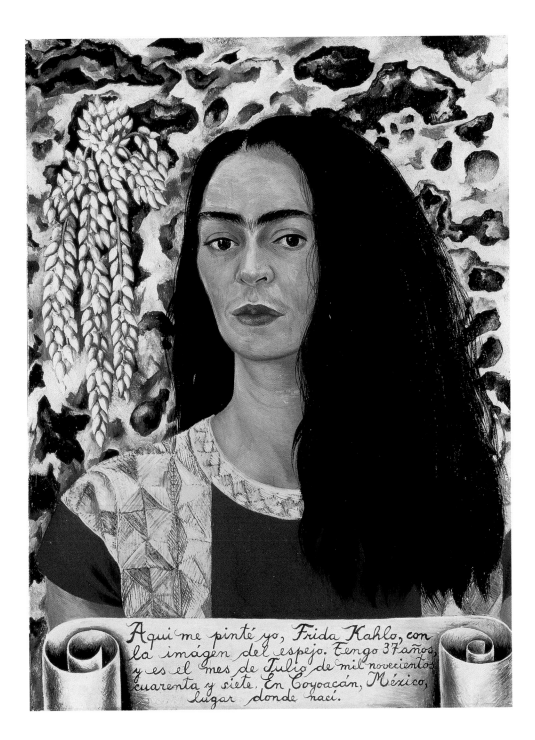

Aqui me pinté yo, Frida Kahlo, con la imágen del espejo. Tengo 37 años, y es el mes de Julio de mil novecientos cuarenta y siete. En Coyoacán, México, lugar donde nací.

Symbol of femininity Frida seldom painted her hair loose; usually it was tied up elaborately. In this painting, she seems almost to be showing off her dark, flowing locks, which represent the feminine beauty and sensuality she has regained after being reunited with Diego.

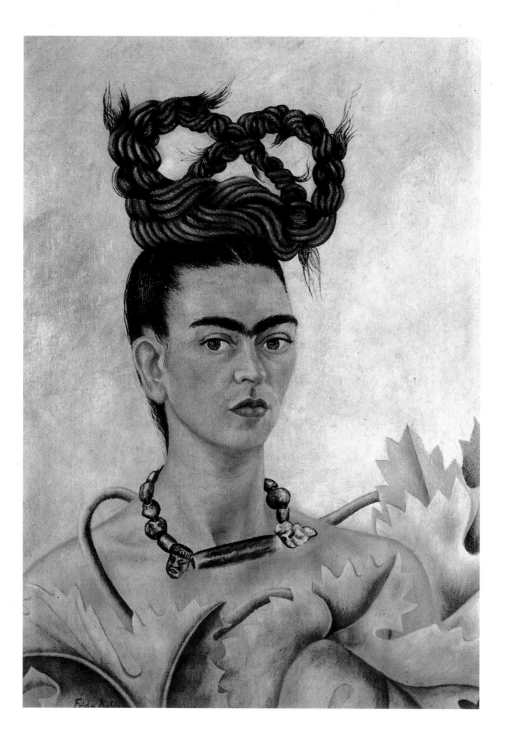

Extravagant headdress Frida's highly individual plaits are reminiscent of hairstyles from the Mexican state of Oaxaca. Lengths of wool can barely tame Frida's unruly hair, which is tied up in the shape of the figure eight, the symbol for infinity.

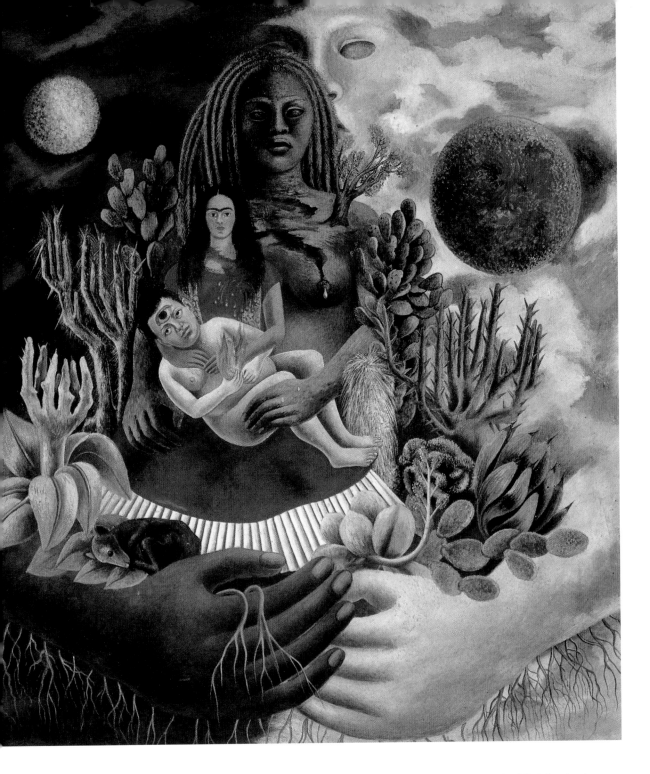

Cosmic family Cradled by Mother Earth, Frida tenderly rocks a naked Diego on her lap. Her favorite dog, Señor Xólotl, lies sleeping on the arm of the all-protecting figure of the cosmos. After divorcing and then re-marrying Diego, Frida's relationship with him became more and more maternal, and her attachment to him even stronger.

Frida Today

"Women today can learn from Frida: she always did what she wanted, and did not content herself with the role of dumb female."

Salma Hayek,
actress

Frida's life and works ...

... are now well known. She is popular as never before, and is a source of inspiration not only to artists, but also to film producers, composers, writers, choreographers, and even fashion designers. We come closest to her in her family home in Coyoacán, the Blue House. It is now a museum that attracts large numbers of visitors. Numerous books and films also convey a lively impression of Frida's world.

Back to roots

Frida lived and worked in the Blue House, or Casa Azul, in Coyoacán, now part of Mexico City. Concealed behind cobalt-blue walls, her colorful world has been open to visitors as the Frida Kahlo Museum since 1958. Her wheelchair is still in her studio, her four-poster bed is still in her bedroom, her splendid dresses still hang in her wardrobes. Nowhere else is Frida's spirit so alive. The Blue House is not the only place of pilgrimage for visitors in search of Frida in Mexico City, however: the Dolores Olmedo Patiño collection is also open to the public, as is Diego's Museo Anahuacalli.

Frida's easel in the Blue House: she was unable to complete this portrait of Stalin.

Don't miss ...

→ **Hayden Herrera's fascinating biography of Frida, which triggered today's Frida mania.**

→ **Julie Taynor's film** *Frida*, **with Salma Hayek in the leading role.**

Famous admirers

Frida has had famous admirers not only during lifetime. Today, too, prominent figures are among her biggest fans. Madonna was one of the first to rediscover Frida after years of obscurity. Both she and Jennifer Lopez wanted to produce a film about Frida's life and even to play the leading role, but their plans came to nothing. At least Madonna can console herself with the knowledge that she owns two of Frida's paintings.

Princely sums

Even during her lifetime, Frida was able to sell her paintings to collectors and patrons for good money. Yet she would probably never have dared dream of the status her works enjoy in the art market today. Nowadays, her paintings achieve high prices: at Christie's in New York, an incredible $3.2 million was bid for one of her portraits – more than was ever paid for anything by Diego! The new owner can think him- or herself lucky: it is not often that a painting by Frida comes onto the open market.

Frida and fashion

Frida always set great store by her appearance. In her splendid Tijuana costumes, she looked like a colorful bird of paradise. French *Vogue* magazine recognized her potential on her visit to Paris in 1939, and published a photograph of her ring-covered fingers on its cover. But who back then would have thought that fashion designers today would devote whole collections to her? As Frida mania took hold, 'ethnic Mexican' has become *très chic* and has been seen on the catwalks of Paris, London, and New York. Even famous designers such as Jean Paul Gaultier have been inspired by Frida (right).

The Mexican actress Salma Hayek made a dream come true when she played the role of Frida.

Frida, played by Salma Hayek, dancing with
Tina Modotti, played by Ashley Judd.

Frida Kahlo superstar

What would Frida say if she knew about the cult that now surrounds her? Towards the end of her life, she enjoyed fame and honors, but after her death her work was forgotten. No one could have imagined the Frida mania that exists today.

An impressive comeback

It is women who have again drawn our attention to Frida Kahlo. Memories of the flamboyant artist were beginning to fade by 1966 when the art historian Hayden Herrera saw a documentary film in which friends and students had a chance to talk about Frida. Her unique story haunted Herrera, who then became engrossed in the forgotten artist's life and work. Herrera's biography of Frida was published in 1983 and became a bestseller; it remains unsurpassed to this day. Not long before, in the late 1970s, a major exhibition in Chicago helped to bring Frida's paintings to public attention again. Her works were later shown in Europe, where they were also enthusiastically received.

Madonna admits to being a great fan of Frida: "Frida is the great inspiration of my life!"

> "Not caring one bit, she did what she wanted – even if everybody was against her. That's how I'd like to be – but I'm still having to work at it!"
>
> **Salma Hayek**

The director Julie Taymor, who, along with Salma Hayek, made the award-winning feature film *Frida*.

Frida everywhere

While *Frida* was the most successful film to be made about the artist, it was not the first. In 1984, Paul Léduc directed *Una vida abierta*, and in 1989 Mary Lance dealt with the story of Diego's life and loves in *Diego Rivera: I Paint What I See*. In 2000, Liz Crow made a short experimental film called *Frida Kahlo's Corset*. Frida has inspired not

The singer even owns two of her paintings, one of them being *Birth or My Birth* (page 35), which is said to hang in her bedroom.

Frida's posthumous fame received a huge boost with a keenly awaited feature film about her directed by Julie Taymor. Released in 2002, *Frida* captivated millions and won two Oscars. The Mexican actress Salma Hayek had struggled for eight years to have the film made. Playing the lead role meant the fulfillment of a lifetime's dream for her: "She's been part of my life since I was fourteen, and she's still there. She's in my heart."

only film producers, but also theater directors, choreographers, and composers: there are several plays about her, there is Johann Kresnik's ballet *Frida Kahlo*, and a *Suite for Frida Kahlo* that the James Newton Ensemble dedicated to her. Even fashion designers have fallen under her spell: in 1997, Paola Frani designed a whole collection around the artist, while a year later Jean Paul Gaultier also had his models striding along the catwalk à la Frida. Those unable to afford top-class designer outfits, but who still choose not to forgo a touch of Kahlo, should take

Frida's Closet is a boutique in Brooklyn where shopping à la Frida is possible. Nowhere else has a range of goods that is more inspired by the world of Frida Kahlo (below).

a look at the website www.fridakahlo.us. Besides clothes, this website offers bags, jewelry, and lots of other accessories that in some way recall Frida. And when next in Brooklyn, it's well worth visiting *Frida's Closet*, a small boutique whose range pays homage to Frida (www.fridascloset.com). And if that is not enough, there are countless fan pages available on the Internet containing the most bizarre declarations of love. Enter 'Frida Kahlo' in a search engine and you're off on a remarkable journey!

Open house

There is no doubt, however, that we come closest to Frida in the place where she was born and in which she spent a large part of her life: the Blue House in Mexico City. After her death, Diego Rivera left the house to the Mexican nation. Four years later it opened as a museum for all. Refurbished in the early 1990s, the house is resplendent in its glorious original colors. It looks as if Frida could walk through the door at any moment.

Bedroom It seems as if Diego has just left his bedroom in the Blue House, which is now a museum. His hats, bags, a pair of shoes, and his coat lie around the room, his alarm clock stands on the bedside table. A portrait photograph taken by his rival Nickolas Muray (page 97) hangs above the bed.

A feast for the eyes Frida and Diego's dining room offered more than culinary delights: it also contained a splendid array of the pre-Columbian and Mexican folk art they collected. The inscription on the wall opposite reads: "Frida and Diego lived in this house 1929–1954."

Blue House The Blue House takes its name from the color of its walls. With its exotic plants and pre-Columbian figures, the courtyard, now as then, is an oasis of peace for visitors.

The cult of Frida Enthusiasm for Frida takes strange forms in the American state of New Mexico. In 2002, a look-alike competition was held that allowed Frida's admirers to be Frida for a day.

Picture list:

P. 5: Emiliano Zapata (1879–1919), photograph by Augustín Casasola.

P. 6: Unknown artist from Oaxaca, *Heart*, 20th century, painted metal, height 25 cm, private collection.

P. 7 above: Emiliano Zapata (1879–1919), photograph.

P. 7 below left: Diego Rivera, *History by Cuernavaca and Morelos, Conquest and Revolution*, 1930/31, mural, photograph of the loggia, Museo Quaunahuac, Instituto Nacional de Antropología e Historia/INAH, Cuernavaca, Morelos.

P. 8: Diego Rivera, *Burning of Judas*, 1923/24, mural, 4.43 x 2.14 m, Ministry of Education, Mexico City.

P. 9: Mexican revolutionaries, photograph.

P. 10: Porfirio Díaz (1830–1915), photograph.

P. 11 on left: Unknown artist, *Maria and Child and the Crucified Christ*, Mexican retablo, 36.1 x 25.4 cm, private collection.

P. 11 on right: José Clemente Orozco, *American Civilization–Latin America*, detail from a mural sequence depicting the evolution of civilization in the Americas, 1932, 3 x 3 m. Commissioned by the Trustees of Dartmouth College, Hanover, New Hampshire.

P. 12: Diego Rivera, *Working on a Mural*, 1931, mural, 5.68 x 9.91 m, San Francisco Art Institute, San Francisco.

P. 13: Diego Rivera, *The End of Capitalism*, from the second *Corrido* cycle (detail), 1926–1928, mural, Ministry of Education, Mexico City.

P. 15: Frida Kahlo in traditional Tijuana costume, 1940, photograph by Bernhard G. Silberstein.

P. 16: The Statue of Liberty, New York.

P. 17 above: Musée du Louvre, Paris.

P. 17 below: Frida Kahlo, *Portrait of Doña Rosita Morillo*, 1944, oil on canvas, mounted on board, 76 x 60.5 cm, Museo Dolores Olmedo Patiño, Mexico City.

P. 18: Frida Kahlo, *Self-Portrait on the Borderline between Mexico and the United States* (detail), 1932, oil on metal, 31 x 35 cm, private collection, New York.

P. 19: Frida Kahlo showing the American collector Helena Rubinstein and Emmy Lou Packard watercolors by Diego Rivera, *c.* 1940.

P. 20: Frida Kahlo, *Portrait of my Father*, 1951, oil on board, 60.5 x 46.5 cm, Diego Rivera and Frida Kahlo Museum, Mexico City.

P. 21 left: Frida Kahlo, *Portrait of Diego Rivera*, 1937, oil on wood, 46 x 32 cm, Collection of Jacques and Natasha Gelman, Mexico City.

P. 21 right: Frida Kahlo standing in front of an incomplete mural by Diego in the New Workers' School, New York, 1933, photograph by Lucienne Bloch.

P. 22 left: Philip L. Goodwin and Edward D. Stone (designers), Museum of Modern Art, New York, 1939.

P. 22 right: Julien Levy, *c.* 1932, photograph by Jay Leyda.

P. 23: Frida Kahlo in hospital, 1952, photographed by Juan Gunzmán.

P. 24: Frida Kahlo, *Self-Portrait*, 1930, oil on canvas, 65 x 55 cm, Museum of Fine Arts, Boston.

P. 25: Frida Kahlo, *The Suicide of Dorothy Hale*, 1939, oil on board, with a painted frame, 60.4 x 48.6 cm, Phoenix Art Museum, Phoenix, Arizona.

P. 26/27: Frida Kahlo, *Moses or Nucleus of Creation*, 1945, oil on board, 61 x 75.6 cm, private collection, Houston, Texas.

P. 29: Frida Kahlo, *Self-Portrait with the Portrait of Dr Farill* (detail), 1951, oil on board, 41.5 x 50 cm, private collection, Mexico City.

P. 30: Small vessel depicting the god Quetzalcoatl in the maw of a beast, *c.* 1000–1250 AD. Pottery with mother-of-pearl and ivory, height 12.5 cm, Museo Nacional de Antropología, Mexico.

P. 31 above: Unknown artist, *retablo*, 1920, 44.4 x 35.5 cm, Calderela Antiques, Jack Calderela.

P. 31 below: Salvador Dalí, *Dismal Sport*, 1929, oil and collage on canvas, 31 x 41 cm, private collection.

P. 32: Frida Kahlo, *My Wet Nurse and I*, 1937, oil on metal, 30.5 x 34.7 cm, Museo Dolores Olmedo Patiño, Mexico City.

P. 33: Frida Kahlo, *Roots or The Pedregal*, 1943, oil on metal, 30.5 x 49.9 cm, private collection, Houston, Texas.

P. 34: Frida Kahlo, *Self-Portrait with Thorny Necklace*, 1940, oil on canvas, 63.5 x 49.5 cm, Austin, Texas, Harry Ransom Humanities Research Center Art Collection, University of Texas.

P. 35: Frida Kahlo, *Birth or My Birth*, 1932, oil on metal, 30.5 x 35 cm, private collection.

P. 36: Juan Gris, *Fantomas*, 1915, oil on canvas, 59.8 x 73.3 cm, Chester Dale Fund, National Gallery, Washington, DC.

P. 37 left: Frida Kahlo, *Self-Portrait with Diego and my Dog*, *c.* 1953/54, oil on board, 59.7 x 40 cm, whereabouts unknown.

P. 37 right: Frida Kahlo, *Viva la Vida (long live life!)*, *c.* 1951–1954, oil and earth on board, 52 x 72 cm, Diego Rivera and Frida Kahlo Museum, Mexico City.

P. 38: Frida Kahlo, *Self-Portrait with Velvet Dress*, 1926, oil on canvas, 79.7 x 60 cm, estate of Alejandro Gómez Arias, Mexico City.

P. 39: Frida Kahlo, *What I Saw in the Water or What the Water Gave Me*, 1938, oil on canvas, 91 x 70.5 cm, private collection.

P. 40: Frida Kahlo, *Self-Portrait with Monkey and Dog*, 1945, oil on board, 60 x 42,5 cm, Museo Dolores Olmedo Patiño, Mexico City.

P. 41: Frida Kahlo, *Self-Portrait with Monkey*, 1940, oil on board, 55.2 x 43.5 cm, private collection, USA.

P. 43: Frida Kahlo, hair growing again, on one of her visits to Xochimilco, Mexico, photograph by Guillermo Davila.

P. 44: Frida Kahlo aged about five with relatives including her two sisters Matilde (rear left) and Adriana (front right), 1912, photograph by Guillermo Kahlo.

P. 45 above: Frida Kahlo, *Accident*, 1926, pencil on paper, 20 x 27 cm, private collection.

P. 45 below: Frida Kahlo, *Marxism Will Give Health to the Sick* (detail), see p. 82.

P. 46: Frida Kahlo, 16 October 1932, photograph by Guillermo Kahlo.

P. 47: *What I Saw in the Water or What the Water Gave Me* (detail), see p. 39.

P. 48: Guillermo Kahlo and Matilde Calderón on the day of their marriage, 1898.

P. 49 left: Frida Kahlo aged four, 1911, photograph by Guillermo Kahlo.

P. 49 right: Frida Kahlo and relatives. From left to right: sisters Adriana and Cristina, Frida, and cousins Carmen Romero and Carlos Veraza, February 1926, photograph by Guillermo Kahlo.

P. 50: *Retablo*, re-touched by Frida, *c.* 1943, oil on metal, 19.1 x 24.1 cm, private collection.

P. 51 left: Diego Rivera at a Communist Party rally, 1920s.

P. 51 right: Diego Rivera, *Arsenal – Frida Kahlo Distributing Weapons*, detail from the cycle *The Ballad of the Proletarian Revolution*, 1928, 2 x 4 m, courtyard of the Secretaría de Educación Pública-SEP, Mexico City.

P. 52: Frida Kahlo, *Frieda* [sic] *Kahlo and Diego Rivera or Diego and Frieda*, 1930, pencil and ink on paper, 29.2 x 21.6 cm, Austin, Texas, Harry Ransom Humanities Research Center Art Collection, University of Texas.

P. 53: Frida Kahlo, *Portrait of Dr Leo Eloesser*, 1931, oil on board, 85.1 x 59.7 cm, University of California, School of Medicine, San Francisco.

P. 54: Frida Kahlo, *Portrait of Alicia Galant*, 1927, oil on canvas, 107 x 93.5 cm, Museo Dolores Olmedo Patiño, Mexico City.

P. 55: Frida Kahlo, *My Grandparents, My Parents and I*, 1936, oil and tempera on metal, 31 x 34 cm, Museum of Modern Art, New York, donated by Allan Roos, MD, and B. Matheu Roos.

P. 56: Frida Kahlo, *Self-Portrait as a Tijuana or Diego in My Thoughts or Thoughts of Diego*, 1943, oil on board, 76 x 61 cm, Jacques and Natasha Gelman Collection, Mexico City.

P. 57: Frida Kahlo, *Portrait of Luther Burbank*, 1931, oil on board, 86.5 x 61.7 cm, Museo Dolores Olmedo Patiño, Mexico City.

P. 58: Frida Kahlo, *Frida and the Miscarriage*, 1932, lithograph, 32 x 23.5 cm, Museo Dolores Olmedo Patiño, Mexico City.

P. 59: Frida Kahlo, *Henry Ford Hospital or The Flying Bed*, 1932, oil on metal, 30.5 x 38 cm, Museo Dolores Olmedo Patiño, Mexico City.

P. 60: Frida Kahlo, *My Dress Hangs There or New York*, 1933, oil and collage on board, 46 x 50 cm, Hoover Gallery San Francisco, heirs of Dr Leo Eloesser.

P. 61: Frida Kahlo, *Self-Portrait with Necklace*, 1933, oil on metal, 34.5 x 29.5 cm, Jacques and Natasha Gelman Collection.

P. 62: The architect Albert Kahn, Frida Kahlo, and Diego Rivera at the Detroit Institute of Arts, 1932.

P. 63 left: Frida with shorn hair, photograph by Lucienne Bloch, 1935.

P. 63 right: Diego Rivera, *Workers of the World, Unite in the Fourth International*, detail from *Man at the Crossroads*, 1932, Mural, Palace of Fine Arts, Mexico City.

P. 64 above: Frida Kahlo, 1938, photograph by Julien Levy.

P. 64 below: Frida Kahlo welcoming Leon Trotsky in Mexico.

P. 65: Marcel Duchamp, photograph.

P. 66: Frida Kahlo, *Self-Portrait Dedicated to Leon Trotsky or Between the Curtains*, 1937, oil on canvas, 87 x 70 cm, The National Museum of Women in the Arts, Washington, DC.

P. 67: Frida Kahlo, *Self-Portrait with Itzcuintli Dog, c.* 1938, oil on canvas, 71 x 52 cm, private collection, United States.

P. 68: Frida Kahlo, *Self-Portrait 'The Frame,' c.* 1938, oil on aluminium and glass, 29 x 22 cm, Musée National d'Art Moderne, Centre Georges Pompidou, Paris.

P. 69: Frida Kahlo, *The Two Fridas*, 1939, oil on canvas, 173.5 x 173 cm, Museo de Arte Moderno, Mexico City.

P. 70: Frida Kahlo, *The Broken Column*, 1944, oil on canvas mounted on board, 40 x 30.7 cm, Museo Dolores Olmedo Patiño, Mexico City.

P. 71: Frida Kahlo, *Tree of Hope, Keep Strong*, 1946, oil on board, 55.9 x 40.6 cm, private collection.

P. 72: Frida Kahlo, *Self-Portrait with Monkeys*, 1943, oil on canvas, 81.5 x 63 cm, Jacques and Natasha Gelman Collection, Mexico City.

P. 73: Frida Kahlo and Diego Rivera at a political rally, 1946.

P. 74: Frida at the opening of her first solo exhibition in Mexico, 1953.

P. 75 left: Two pages from Frida Kahlo's diary, 1953, mixed media on paper, Diego Rivera and Frida Kahlo Museum, Mexico City.

P. 75 right: Diego Rivera and Frida Kahlo at a political rally in Mexico City, 1954.

P. 76: Two pages from Frida Kahlo's diary, 1946–1954, mixed media on paper, Diego Rivera and Frida Kahlo Museum, Mexico City.

P. 77: Two pages from Frida Kahlo's diary, 1946–1954, mixed media on paper, Diego Rivera and Frida Kahlo Museum, Mexico City.

P. 78: Frida Kahlo, *Fruits of the Earth*, 1938, oil on board, 40.6 x 60 cm, Banco National de México, Fomento Cultural Banamex, Mexico City.

P. 79: Frida Kahlo, *Sun and Life*, 1947, oil on board, 40 x 50 cm, private collection.

P. 80: Frida Kahlo, *Flower of Life*, 1943, oil on board, 27.8 x 19.7 cm, Museo Dolores Olmedo Patiño, Mexico City.

P. 81: Frida Kahlo, *The Circle*, 1951, oil on aluminium on wood, 15 cm diameter, Museo Dolores Olmedo Patiño, Mexico City.

P. 82: Frida Kahlo, *Marxism Will Give Health to the Sick*, *c.* 1954, oil on board, 76 x 61 cm, Diego Rivera and Frida Kahlo Museum, Mexico City.

P. 83: Frida Kahlo, *Self-Portrait with Stalin or Frida and Stalin*, *c.* 1954, oil on board, 59 x 39 cm, Diego Rivera and Frida Kahlo Museum, Mexico City.

P. 85: Frida Kahlo and Diego Rivera on their wedding day in August 1929.

P. 86: Frida Kahlo, *Frida and Diego Rivera or Frida Kahlo and Diego Rivera*, 1931, oil on canvas, 100 x 79 cm, San Francisco Museum of Modern Art, San Francisco.

P. 87 above: Frida Kahlo, *Portrait of My Sister Cristina*, 1928, oil on wood, 99 x 81.5 cm, private collection, Caracas.

P. 87 below: Leon Trotsky, photograph.

Cover:

Front cover: Frida Kahlo, *Self-Portrait with Necklace* (detail) (page 61).

Back cover: Frida Kahlo, *Self-Portrait with the Portrait of Dr Farill* (detail) (page 29).

Outside front flap: Frida Kahlo, hair growing again, on one of her visits to Xochimilco, Mexico (page 43).

Inside front flap, top l. to r.: Lenin's casket in the in the Lenin Mausoleum in Moscow, 1924; "Black Tuesday" at the New York Stock Exchange, 1929; German troops cross the border into Poland, 1929; Mao Tse-Tung; Elvis Presley; Humphrey Bogart and Ingrid Bergman in *Casablanca*; below l. to r. (all works by Frida Kahlo unless otherwise specified): *My Grandparents, My Parents, and I* (page 55), *Accident* (page 45, above), *Frida and Diego Rivera* or *Frida Kahlo and Diego Rivera* (page 86), *Henry Ford Hospital* or *The Flying Bed* (page 59), *Tree of Hope, Keep Strong* (page 71), *Viva la Vida* (page 37, right), Diego Rivera, *Self-Portrait Dedicated to Irene Rich* (page 91, right), courtyard of the Blue House.

Inside back flap, top l. to r.: Frida Kahlo, aged four (page 49, left); Frida Kahlo aged 18, 1926 [Photo from Guillermo Kahlo], Frida Kahlo and Diego Rivera on their wedding day in August 1929 (page 85), Frida Kahlo welcoming Leon Trotsky in Mexico (page 64, below), Frida Kahlo in traditional Tijuana costume (page 15), Frida Kahlo and Diego Rivera at a political rally (page 73), Frida Kahlo in hospital (page 23), Diego Rivera beside Frida Kahlo's coffin (page 101); below l. to r. (all works by Frida Kahlo): *My Grandparents, My Parents and I* (page 55), *Self-Protrait with Velvet Dress* (page 38), *Self-Portrait* (page 24), *Self-Portriat Dedicated to Leon Trotsky of Between the Curtains* (page 66), *Self-Portrait "The Frame"* (page 68), *Self-Portrait with Cropped Hair* (page 108), *The Broken Column* (page 70), *Self-Portrait with Monkey and Dog* (page 40), *Self-Portrait with Diego and My Dog* (page 37, left).

If you want to know more

Two key biographies:

Hayden Herrera, *Frida: A Biography*, New York / Harper & Row, 1983.

Raquel Tibol, *Frida Kahlo: An Open Life*, Albuquerque / University of New Mexico Press, 1993.

Studies of Frida's life and works:

Sarah M. Lowe, *Frida Kahlo*, New York / Universe, 1991.

Malka Drucker, *Frida Kahlo: Torment and Triumph in Her Life and Art*, with an introduction by Laurie Anderson, New York / Bantam, 1991.

Gerry Souter, *Frida Kahlo: Beneath the Mirror*, New York / Parkstone, 2005.

Martha Zamora, *Frida Kahlo: The Brush of Anguish*, San Francisco / Chronicle Books, 1990.

Isabel Alcántara and Sandra Egnolff, *Frida Kahlo and Diego Rivera*, New York and London / Prestel, 1999.

Robin Richmond, *Frida Kahlo in Mexico*, San Francisco / Pomegranate Artbooks, 1994.

In Frida's own words:

The Letters of Frida Kahlo, compiled by Martha Zamora, San Francisco / Chronicle Books, 1995.

The Diary of Frida Kahlo: An Intimate Self-Portrait, introduction by Carlos Fuentes, essay and commentaries by Sarah M. Lowe, New York / H.N. Abrams, 1995.

I Will Never Forget You: Frida Kahlo to Nickolas Muray, unpublished photographs and letters, edited by Salomón Grimberg, London / Tate Publishing, 2005.

Frida on film:

Frida Kahlo, film produced by Eila Hershon, Roberto Guerra, and Wibke Von Bonin, Chicago / RM Arts – Home Vision, 1983.

The Life and Times of Frida Kahlo, film by Amy Stechler, Washington, DC / Daylight Films and WETA, in association with Latino Public Broadcasting, 2005.

And for those interested in the celebrated film by Julie Taymor, the screenplay (with other texts) is available:

Frida, screenplay by Clancy Sigal, Diana Lake, Gregory Nava, and Anna Thomas, foreword by Hayden Herrera, and introductions by Julie Taymor and Salma Hayek, New York / Newmarket Press, 2002.

Internet:

There are many websites, good and bad, on the Internet.

Imprint

The pictures in this book were graciously made available by the museums and collections mentioned, or have been taken from the Publisher's archive with exception of:
Rafael Doniz: Pages 7 below, 20, 21 left, 29, 32, 37 right, 40, 45, 51 below, 54, 56, 72, 78, 79, 82, 83, 90, 106, 107
Bob Schalkwijk, Mexico City: Page 8
David Wakeley, San Francisco: Page 12
Museum of Fine Arts, Boston: Page 24
Christie's, New York. Pages 37 left, 103
Laura Cohen: Pages 114, 120, 121, 122
Picture Press/CAMERA PRESS/© ROTA: Page 115 above
Picture Press/Everett Collection/Miramax. Pages 116, 117
Courtesy Jean-Paul Gautier: Page 115 below
© Reuters/CORBIS: Page 118
Courtesy Frida's Closet, New York: Page 119
Getty Images: Page 123
Musée National d'Art Moderne, Centre Georges Pompidou, Paris: Page 68
Archivo CENIDAP-INBA, Mexico City: Pages 23, 43, 64 below, 74 85, 87 above
Javier Hinojosa: Page 58, 80, 81 98
Jorge Contreras: Cover, Page 61
akg, Berlin: Page 17 below, 26/27, 33, 57, 59, 66. 69, 70, 89, 104, 105, 109
© The Detroit Institute of Arts: Page 62
Courtesy George Eastman House: Page 97

© for the illustrated works of Frida Kahlo and Diego Rivera with Banco de México Diego Rivera & Frida Kahlo Museums Trust. Av. Cinco de Mayo No. 2, Col. Centro, Del. Cuauhémoc 06059, México, D.F.

© for the illustrated works of Salvador Dalí with Salvador Dalí. Foundation Gala-Salvador Dalí / VG Bild-Kunst, Bonn 2007

The Library of Congress Control Number: 9783791337807
British Library Cataloguing-in-Publication Data: a catalogue record for this book is available from the British Library. The Deutsche Bibliothek holds a record of this publication in the Deutsche Nationalbibliografie; detailed bibliographical data can be found under: http://dnb.ddb.de

© Prestel Verlag, Munich · Berlin · London · New York 2007

Prestel Verlag
Königinstrasse 9
80539 Munich
Tel. +49 (89) 38 17 09-0
Fax +49 (89) 38 17 09-35

Prestel Publishing Ltd.
4, Bloomsbury Place
London WC1A 2QA
Tel. +44 (0) 20 7323-5004
Fax +44 (0) 20 7636-8004

Prestel Publishing
900 Broadway. Suite 603
New York, N.Y. 10003
Tel. +1 (212) 995-2720
Fax +1 (212) 995-2733

www.prestel.com

Editorial direction by Claudia Stäuble and Reegan Finger
Translated from the German by Stephen Telfer
Copy-edited by Chris Murray
Series editorial and design concept by Sybille Engels, engels zahm + partner
Cover, layout, and production by Wolfram Söll
Lithography by Reproline Genceller
Printed and bound by Druckerei Uhl GmbH & Co.KG, Radolfzell

Printed in Germany on acid-free paper

ISBN 978-3-7913-3780-7